IMAGES
*of America*

# GUYANDOTTE

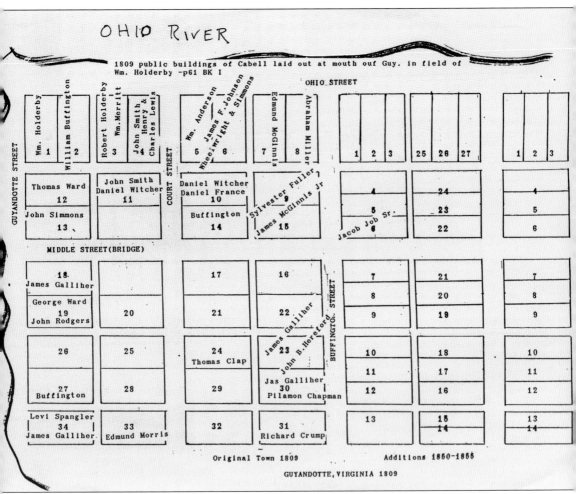

**OHIO RIVER**

1809 public buildings of Cabell laid out at mouth ouf Guy. in field of Wm. Holderby -p61 BK I

This 1809 map, made a year before the town of Guyandotte, Virginia, was chartered, shows that the village—as originally laid out—was small indeed. Few businesses existed at the time, and many of the land parcels were not labeled with owners' names. (Courtesy of the Cabell County, West Virginia, County Clerk's Office.)

**ON THE COVER:** Pictured on the cover are members of the Clark family, preparing to evacuate their fine home at 524 Main Street as the flood of March 1907 reaches the front porch. Before a flood wall was built in the 1940s, Guyandotte was ravaged again and again when the waters of the Ohio and Guyandotte Rivers overflowed their banks. (Courtesy of Mrs. Jack Hines.)

IMAGES
*of America*

# GUYANDOTTE

Bob Withers

ARCADIA
PUBLISHING

Published by Arcadia Publishing
Charleston, South Carolina

Printed in the United States of America

Library of Congress Control Number: 2013948888

For all general information, please contact Arcadia Publishing:
Telephone 843-853-2070
Fax 843-853-0044
E-mail sales@arcadiapublishing.com
For customer service and orders:
Toll-Free 1-888-313-2665

Visit us on the Internet at www.arcadiapublishing.com

*To my grandmother Mary E. Poindexter Hennen and
my mother, Mary Margaret Hennen Withers, who
entertained me with stories about our town's history*

# CONTENTS

# ACKNOWLEDGMENTS

Without the help of those people and businesses that contributed articles about Guyandotte's history and gladly recorded, acquired, collected, and/or loaned the images you are about to enjoy, this book would not have been possible.

These contributors include Barbara Bias; Scott Barnett; Marshall University's Lisle Brown; Mike Burks; Helen Diddle; Merlyn Allen Diddle; Sam Galloway; Joe Geiger; Irene Stephenson Gustin; William Jennings Bryan Gwinn; Jack Hardin; Mary E. Poindexter Hennen; John Carlton Hennen Jr.; Mrs. Jack Hines; John P. Killoran; Lisa Lafon; Charles Lemley; Bill and Betty Moore; Charlotte Dugan Moore; Nellie M. Moore; Spencer Moore; Bernice Murphy; Creed Neff; Geraldine Withers Perry; J. Bernard Poindexter Sr.; Debbie Richardson; Wilfred Rider; Leonard Samworth Jr.; Mary Ann Saunders; Ruth Sullivan; G.W. "Jerry" Sutphin; George Wallace; Damon and Phyllis Kirk Wilcox; Mary Poindexter Williams; Mary Margaret Hennen Withers; Lori Wolfe; the Cabell County, West Virginia, County Clerk's Office; the Collis P. Huntington Railroad Historical Society Inc.; the US Army Corps of Engineers; and the *Herald-Dispatch*, the daily newspaper of Huntington, West Virginia, for whom the author worked for 38 years.

# INTRODUCTION

Peaceful Delaware and Wyandot Indians are known to have populated the area that is now Guyandotte in the 16th century. Rock quarries where the Indians made arrowheads and petroglyphs have been found and authenticated by the West Virginia Historical Society.

The first white men known to visit the area were French explorer Rene Robert LaSalle and his party in 1670. The first signs of civilization were a crude river landing and a few log cabins.

How Guyandotte got its name is a matter of speculation. One story says it is a corruption of Wyandot. Another contends that French explorer and trader James Guion named the Guyandotte River after himself and the Indians, and then surveyors eventually applied the river's name to the town.

On December 15, 1772, John Murray, the fourth Earl of Dunmore and Virginia's royal governor, acted as agent for King George III in granting 28,627 acres along the Ohio River and the lower Guyandotte and Big Sandy Rivers to John Savage and 59 others who had served under George Washington at the Battle of Great Meadows, Pennsylvania, in the French and Indian War. This "Savage Grant" extended from what is now Catlettsburg, Kentucky, to about Nine Mile Creek in northern Cabell County—about 24 miles. It included the entire original site of Guyandotte.

Although none of the old soldiers are known to have lived on their land, some of the grantees met there in 1775 for a partial division, and descendants or assignees of the 60 men eventually claimed all of the tracts. William Buffington of Hampshire County, in what now is eastern West Virginia, purchased Lot 42 from John Savage himself and willed this parcel to his sons Thomas and Jonathan. In about 1796, Thomas and Jonathan Buffington came to the mouth of the Guyandotte River to take possession. Thomas, a surveyor, bought a home on the east side of the river at its mouth, and Jonathan built on the west side.

The community's growth started almost immediately. In 1802, William Huff was appointed a constable "for the neighborhood of the mouth of the Guyandotte," and a year later, Thomas Buffington established ferry operations across the Guyandotte and Ohio Rivers. Also in 1803, Methodist bishop Frances Asbury, headquartered in Baltimore, sent William Steele to Guyandotte to explore the possibility of launching a congregation there in answer to a petition signed by John Miller and a hundred others requesting "a preacher."

Some sources contend that Asbury himself, who came to America from England in 1771, was among the missionaries on horseback who visited the town as early as 1778. It is said that he visited Guyandotte, organized a congregation, and served as its pastor for 16 years—although he was rarely there—until he appointed Steele as his replacement in 1804, but all that is disputed.

The Western Virginia Conference formed the Guyandotte Circuit in 1804, with the circuit-riding Steele as its first pastor. The Methodists' original brick church was constructed facing west at what is now the corner of Fifth Avenue and Guyan Street, with a cemetery behind it. That

graveyard—believed to be the oldest in Cabell County—is now owned and maintained by the Greater Huntington Park and Recreation District and contains the graves of several Revolutionary War soldiers. A metal casting to honor the memories of those soldiers was affixed to a massive stone pillar in the cemetery on October 29, 1929, the 148th anniversary of the British surrender at Yorktown, Virginia.

In 1805–1807, approximately 8,000 bearskins were shipped from the mouths of the Big Sandy and Guyandotte Rivers. When Cabell County was carved out of Kanawha County in 1809, Guyandotte was designated as its first county seat, and in 1810, the Virginia General Assembly chartered Thomas Buffington's 20 acres as the town of Guyandotte.

River tradesman James Gallaher of Gallipolis, Ohio, floated his home down the Ohio to Guyandotte by flatboat in 1810 and reassembled it on Guyan Street. Thomas Carroll, an Irish carpenter and stonemason, bought the home in 1855, and he and his widow operated it as an "ordinary" (inn) called Carroll House.

By 1831, a daily stagecoach ran from Washington, DC, and Richmond, Virginia, to Guyandotte, where passengers made connections with Ohio River steamboats. The stagecoaches continued until 1873, when Collis P. Huntington's Chesapeake & Ohio (C&O) Railway was completed between Richmond and Huntington, West Virginia, a town three miles west of Guyandotte that the railroad mogul built and named for himself. West Virginia became a state in 1863.

In 1835, Guyandotte contained forty homes, five storehouses, two cabinetmakers, one church, one school, a steam-powered gristmill, a steam-powered sawmill, and a steam-powered wool-carding machine.

Meanwhile, the little Methodist congregation was in a position to generate more history and contribute mightily to the entire region. In addition to its worship services, the original building was the site of the area's first grammar school, which covered the first eight grades. Some years later, the members elected to build a subscription school for higher education, choosing attorney John Laidley as chairman of its board of trustees. Laidley organized the school in 1837 and named it Marshall Academy after US Chief Justice John Marshall who had died two years before. Later, the school became Marshall College, and since 1961, it has been Marshall University.

The Guyandotte church came to be known as the mother of Methodism in the region, since it also spawned the First, Highlawn, Emmanuel, and Johnson Memorial churches in downtown Huntington. Marshall Academy also enabled the members of what is now Huntington's First Presbyterian Church to get their start on the Virginia side of the Ohio River.

Several local businesses incorporated in the years leading up to the Civil War, including the Guyandotte Navigation Co. and the Cabell and Logan Coal Co. The navigation company built locks and dams on the Guyandotte River, which enabled timber companies to float log rafts downriver year-round. Guyandotte's most successful antebellum business was the Buffington Mill, supposedly the largest flour mill on the Ohio River between Pittsburgh and Cincinnati.

Two newspapers were published in Guyandotte before the Civil War. It is thought that one of them, the *Guyandotte Herald*, and *Cabell, Logan and Wayne Advertiser*, was published as early as 1853.

Articles and advertisements alike took on, perhaps, unwittingly, humorous tones. Take for example, this news dispatch appearing in the August 30, 1855, issue: "Queen Victoria says Millard Fillmore is the politest American she ever saw. She has never been west." Or this ad from the same issue: "Beekman & Co. would respectfully request those indebted to them to pay up. They intend laying in their fall stock soon and must have the 'wherewith.'"

The other paper, the *Unionist*, was antislavery and pro-temperance. Advertised items in its September 27, 1856, issue included boots, shoes, liquor, false teeth, lightning rods, notions, patent medicine, dry goods, and tin ware.

As illustrated by the editorial bias of *The Unionist*, residents of the town began choosing sides regarding the slavery issue as early as the 1840s. The Methodist congregation split over the controversy in 1844, with the antislavery faction moving into another building and finally building a large frame church in the 200 block of Bridge Street. Southern sympathizers outnumbered

the opposition, allowing the Southern congregation to outgrow its Guyan Street building. As a result, Robert and Susan Holderby donated land for a new brick church in the 300 block of Main Street in 1848.

As these troublesome times began to fan into open flame, a Baptist congregation built a brick house of worship—complete with green shutters and a balcony reserved for African Americans—in the 200 block of Richmond Street, with the Rev. J.C. Reese as its first pastor.

Once the Civil War broke out, Guyandotte became the hostile host of Camp Paxton, a Union recruiting center. The Main Street Methodist Church and several other buildings in town were commandeered for use as storage depots. There is a story about a Union soldier who fell asleep on a pile of hay in the church's balcony and awoke to find that a cow had managed to get to the hay. Both soldier and bovine were startled, and the cow jumped out of the balcony, breaking her leg. (The author believes the story to be true. Several years ago, when the present sanctuary was being renovated, workers uncovered a piece of a cow's leg bone.)

Guyandotte's split personality was bound to ignite deadly trouble sooner or later. Confederate Col. John Clarkson's 8th Virginia Cavalry and Brig. Gen. Albert Gallatin Jenkins's Border Rangers encircled the town with about 700 horsemen on Sunday evening, November 10, 1861, as many townsfolk and recruits from Camp Paxton were settling down in the pews of the Bridge Street Church to hear the preaching of the Reverend J.C. Wheeler, a Union officer himself. The Confederate forces stormed into town and took control of the camp. When their attack was finished, 10 Union recruits lay dead and at least 10 more had been injured. The Confederates lost three cavalrymen to death and ten more to injuries.

Jenkins had practiced law and served as a congressman before siding with the South in the conflict. He died as the result of a fatal wound received in the Battle of Cloyd's Mountain in Pulaski County, Virginia, on May 9, 1864.

Back in Guyandotte as the Confederates withdrew from town with prisoners in tow, the steamer SS *Boston* appeared, moving slowly up the Ohio from Ceredo, 10 miles west, and carrying about 200 hitchhiking soldiers from the 5th Virginia Infantry who had learned of the attack. The steamboat crew landed briefly at Proctorville, Ohio, to pick up several members of the Ohio Home Guards and then tied up about a mile above Guyandotte on the Virginia side. The Union soldiers and their sympathizers marched into town, and hearing reports of collaboration between some of the townsfolk and the Confederate cavalry, flew into a rage and burned most of the town—including the Buffington mill, the Baptist church, the principal hotels, and the homes of the town's most prominent secessionists. The Union troops melted down the Baptists' bell to make souvenir rings for the troops. The Methodist church was either burned or fell into ruins and was torn down.

Mary Carroll, Thomas Carroll's spunky wife, saved her historic home from the flames. Although ill and confined to bed, she saw the soldiers approaching with lit torches and rushed out into the street, crying and begging the troops to spare the house because she could not move her husband. After some hesitation, the commanding officer ordered his soldiers to extinguish their torches.

Carroll House was historic in another way. Family members were the first Catholics in Cabell County, and their home served as a house of worship before St. Peter's Church was constructed on South High Street in 1873. Fr. Thomas Quirk, parish priest, lived at the Carroll House from 1872 to 1884. He walked many miles to tell Catholic families when the mass would be celebrated. He found several French families in the region, most of whom were Catholic, and they walked long distances in snowstorms or burning summer heat to attend Catholic services in the old home and the new church.

Carroll House also played a role in the community's association with the town's first railroad. It was there that Collis Huntington first came when his surveyors were looking for a place to locate the C&O Railway's original shop buildings. He was offended after his horse, tied up outside the Carroll home, blocked the sidewalk and the mayor fined him $10. Huntington ordered his surveyors to continue their search across the Guyandotte River. Although the town lost its chance to be a major rail terminal, Huntington still frequented the Carroll House to enjoy the gourmet cooking for which it was famous.

An anemic attempt at progress for Guyandotte took place in 1883. George Page and H.C. Everett signed a contract with the Southern Bell Telephone & Telegraph Co. of Richmond to build and operate a single, shaky telephone line from their store on Bridge Street—which was equipped with a wharf boat and sold groceries and timber supplies—three miles west to the new store of Herman Jenkins in downtown Huntington. A year later, the system boasted 30 subscribers, but the venture was not successful and eventually was abandoned.

Despite that brief newfangled amenity, the Civil War had claimed yet another casualty. The town of Guyandotte never recovered from its fiery mortal wound sustained during the Civil War. People began moving to the new town of Huntington, causing Guyandotte to lose some of its most talented leadership. Youngsters left town as soon as they were old enough. Despite the fact that the town staged a gala centennial in 1910, Guyandotte just, in the words of one newspaper report, "quit trying."

In the spring of 1911, not quite a year after the centennial celebration, the idea of Guyandotte being annexed by the City of Huntington was submitted to a vote of the people. On April 11, the town council—Mayor O.H. Wells, recorder C.W. Poindexter, and councilmen James Murphy, John M. Beale, F.A. Knight, R.H. Miller, and Wirt Brown—canvassed the vote and found 260 for and 70 against the plan.

The council declared Guyandotte to be a part of the City of Huntington and adjourned sine die.

# *One*

# PIONEER PERSPECTIVES

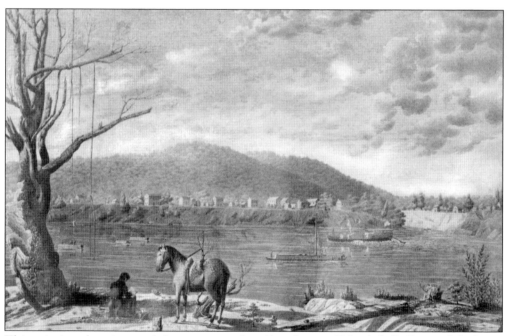

This painting, done in pastels by young traveling French artist Felix-Achille Beaupoil de Saint-Aularie, shows the village of Guyandotte as seen from the Ohio shore in 1823. At least 20 buildings are in sight, as well as a side-wheeler, flatboats, and scows. The artist, de Saint-Aularie, has painted himself and his horse into the scene. (Courtesy of Barbara Bias and Lori Wolfe.)

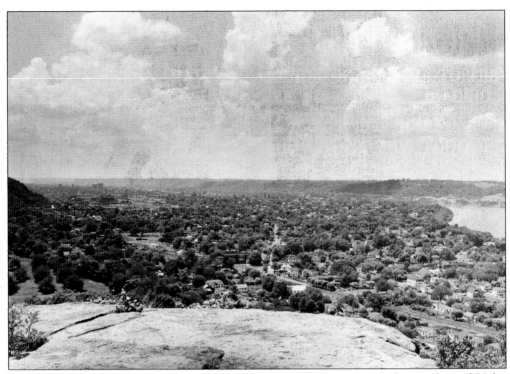

This image was taken in the mid-20th century, but it shows Guyandotte as seen from "the rock cliff," as locals always have called it, which Indians once used as a lookout. Arrowheads and early tools produced by the Delaware and Wyandot tribes have been found in the immediate area surrounding the big rock. (Courtesy of the *Herald-Dispatch*.)

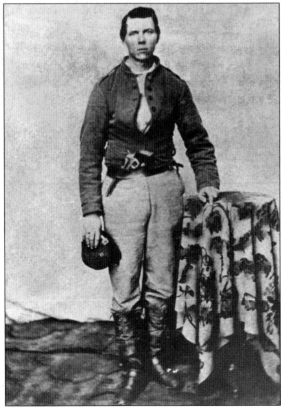

This daguerreotype shows 24-year-old James Albert Poindexter in his Confederate uniform in 1861. He had enlisted in the 8th Virginia Cavalry's Company E—the Border Rangers. Poindexter was captured by Union forces and spent time in a Columbus, Ohio, prison. To pass the time, he carved a ring from a button. His descendants still have the ring and his .45-caliber Remington pistol. (Courtesy of Mary Margaret Hennen Withers.)

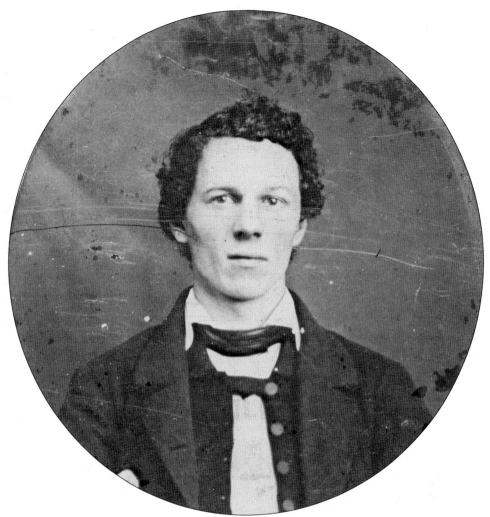

This daguerreotype shows James Albert Poindexter shortly after his Civil War years. He spent more time in prison than was necessary; because of his family's ties to the North, President Lincoln offered to pardon him if he would renounce the Confederacy. He refused and stayed behind bars until the conflict was over. (Courtesy of Mary Margaret Hennen Withers.)

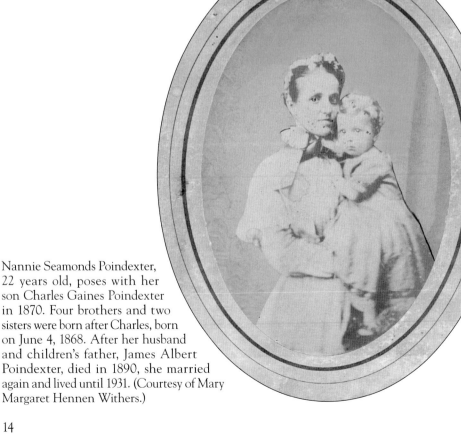

James Albert Poindexter is visible here following the Civil War with his sister Sarah Handley Poindexter, who was seven years younger than he was. They were two of the seven children born to Nicholas Meriwether Poindexter and the former Mary Handley. James Albert died of the grippe (influenza) in 1890. (Courtesy of Mary Margaret Hennen Withers.)

Nannie Seamonds Poindexter, 22 years old, poses with her son Charles Gaines Poindexter in 1870. Four brothers and two sisters were born after Charles, born on June 4, 1868. After her husband and children's father, James Albert Poindexter, died in 1890, she married again and lived until 1931. (Courtesy of Mary Margaret Hennen Withers.)

# *Two*

# THE FAMILY SCRAPBOOK

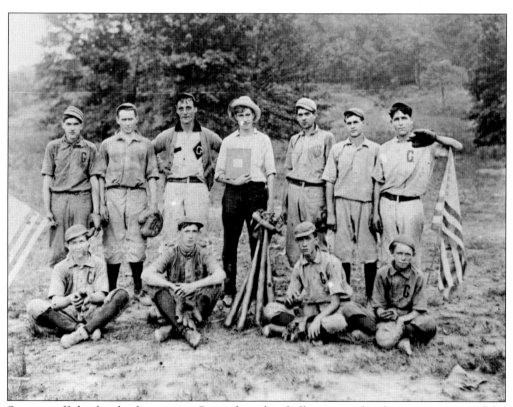

Starting off the family chapter is a Guyandotte baseball team—a family in every sense of the word —in this undated photograph. Owing to the presence of flags, these players may be getting ready to go up against an opponent at a Fourth of July picnic. (Courtesy of Mary Margaret Hennen Withers.)

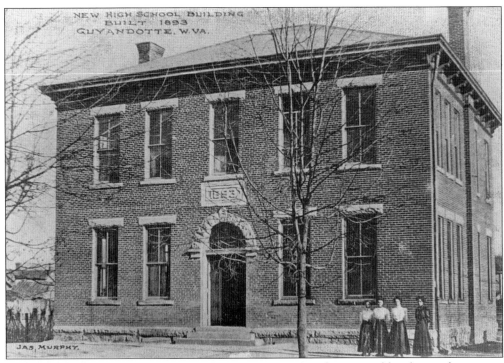

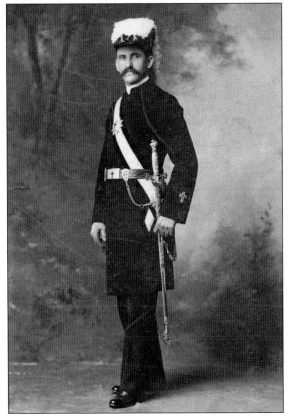

Another type of family was the lodge. Members of Western Star Lodge No. 11 bought the Guyandotte High School building, located at 222 Richmond Street, in 1919 and still occupy it today. In this photograph, teachers pose in front of the 1893 structure. The building also served elementary students twice: when the original elementary school became overcrowded, and once again, when it was being replaced with a much larger one. (Courtesy of Damon Wilcox.)

John C. Hennen poses in his Masonic uniform around 1910. He had advanced to Commandry No. 9. The uniform includes a Knights Templar sword and a chapeau on his head that is topped with ostrich feathers. Freemasonry and its secrets have come under a lot of criticism over the years, but, in fairness, it has also sponsored many good works. (Courtesy of Mary Margaret Hennen Withers.)

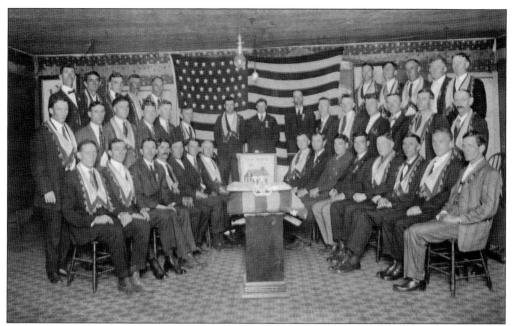

These young men are members of the Junior Order of American Mechanics, posing during a meeting on the second floor of a Guyandotte business in about 1910. Readers with magnifying glasses may be able to detect that the logo on union local 181's podium is a Masonic square-and-compass logo, modified with the strong arm of a mechanic flexing his muscles. (Courtesy of Mary Ann Saunders.)

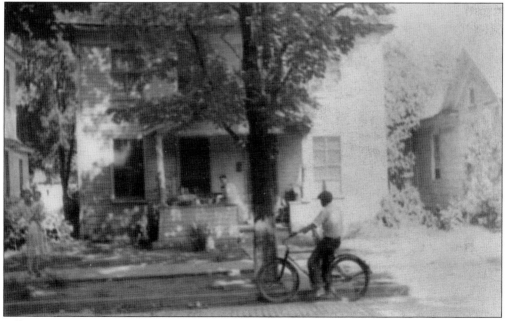

Billy Irene Dunn and his bicycle are caught in a candid pose in front of his home at 312 Main Street in the summer of 1941. His mother, Tressa Lawwill Dunn, sits on the front porch. This peaceful scene belies the fact that in just a few months, an attack on Pearl Harbor would sweep the nation into World War II. (Courtesy of John Carlton Hennen Jr.)

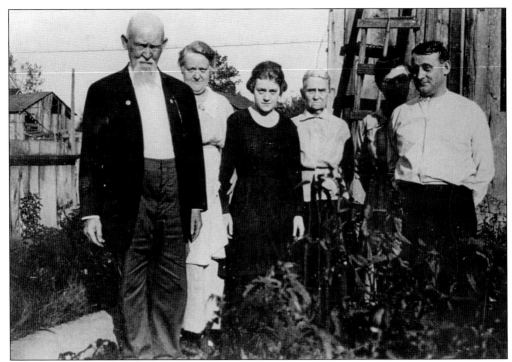

The Moore family poses in Guyandotte around 1915. George Moore, who worked as a telegraph operator and ticket agent for the B&O Railroad in Guyandotte and Huntington for decades, stands at right. His wife, Charlotte Dugan Moore, stands in his shadow. His parents are the first and fourth people from the left. The other two are unidentified. (Courtesy of Mrs. Jack Hines.)

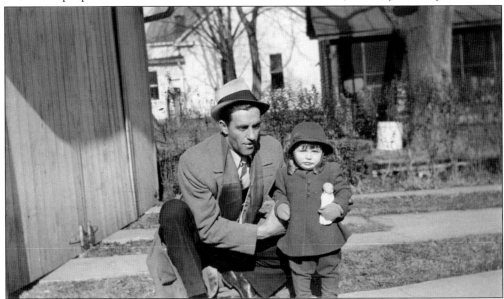

Roderick Garrette poses with his daughter, Jane Ann, in front of John C. Hennen's garage at 313 Main Street in about 1940. Garrette worked for the US post office for years. The white building in the background is the lecture room of the Guyandotte Methodist Episcopal Church–South. (Courtesy of Mary Margaret Hennen Withers.)

Elizabeth Garrette, wife of Rod Garrette, poses in her backyard at 302 Main Street around 1940. She was a Cabell County schoolteacher for decades, working most of that time at Huntington's Gallaher Elementary School. She was a longtime member of Guyandotte Methodist Episcopal Church–South, which was located across the street from her home. (Courtesy of Mary Margaret Hennen Withers.)

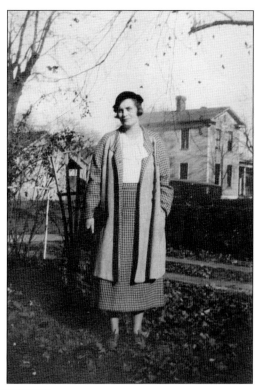

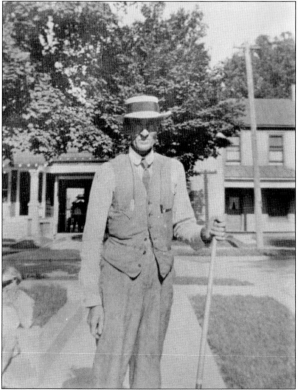

William Henry Wilson, father of Elizabeth Garrette, stands beside the family home at 302 Main Street around 1910. Across Main Street are a firehouse and a private home that were moved out of the way when Guyandotte's Third Street became Huntington's Fifth Avenue and was extended westward to the Guyandotte River to meet a new bridge from the Huntington side. (Courtesy of the *Herald-Dispatch*.)

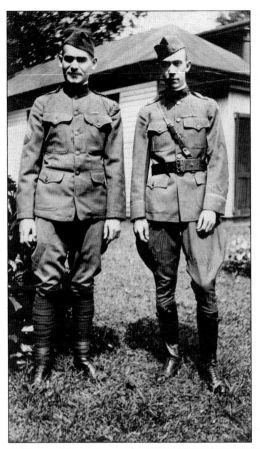

Marion Dusenberry (right) and Julian Taylor pose behind Dusenberry's home at 240 Main Street in this undated photograph. It looks like they are getting ready to go—or have returned from—fighting during World War I. Dusenberry's widow, Mabel, occupied the family home until her death in 1968. (Courtesy of Mary Margaret Hennen Withers.)

Below, Carl Withers and his wife, Mary Margaret, along with his daughters Emogene (left) and Geraldine, grab a bite to eat in a Guyandotte eatery around 1940. The girls' mother, Anna Coleman Withers, died in May 1936, and Carl married the author's future mother, Mary, on December 28, 1938. (Courtesy of Mary Margaret Hennen Withers.)

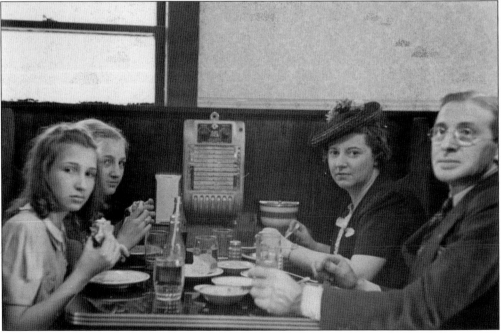

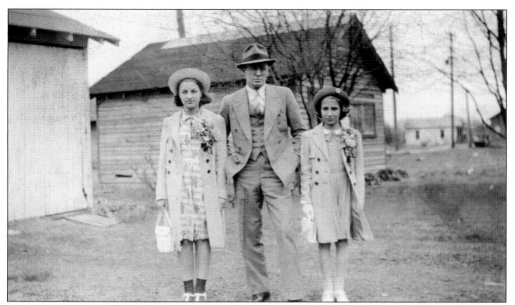

Carl Withers poses with daughters Geraldine (left) and Emogene in front of the family garage at 3606 Third Avenue during the years when Withers had to be both a father and a mother to the girls. Everyone appears to be decked out and ready to go to church on an Easter Sunday. (Courtesy of Mary Margaret Hennen Withers.)

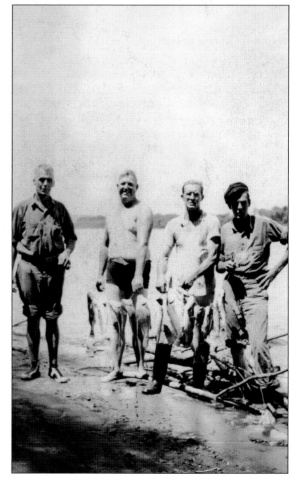

Four hardy fishermen show off their catches from the Ohio River in Guyandotte around 1940. The middle two anglers are brothers Kenneth "Blondie" Withers (left) and Carl Withers. The Withers brothers grew up in Glenwood in Mason County but spent most of their adult lives in Guyandotte. Kenneth was a Huntington firefighter; Carl was an auto mechanic. (Courtesy of Mary Margaret Hennen Withers.)

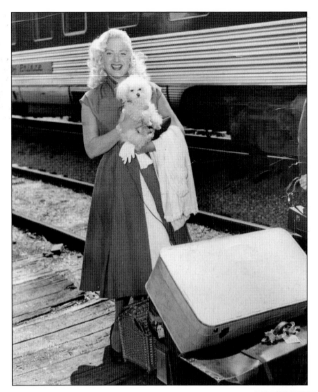

One of Guyandotte's best-known citizens was Virginia Ruth "Ruthie" Egnor, who was known to millions of television viewers as Dagmar in the 1950s. Here, she and her little dog Shakespeare have come home for a family visit on August 12, 1957. Ruthie's big break came in 1950 or 1951, when she starred with Jerry Lester and Morey Amsterdam on NBC's *Broadway Open House*. (Courtesy of the *Herald-Dispatch*.)

After a long career in show business, Dagmar's health failed, and she came home to live with relatives. Here, she poses in the author's home while taking a break touring her old Guyandotte neighborhood. She began attending the author's church and eventually accepted the Lord Jesus Christ as her Savior. She died in 2001. (Courtesy of Bob Withers.)

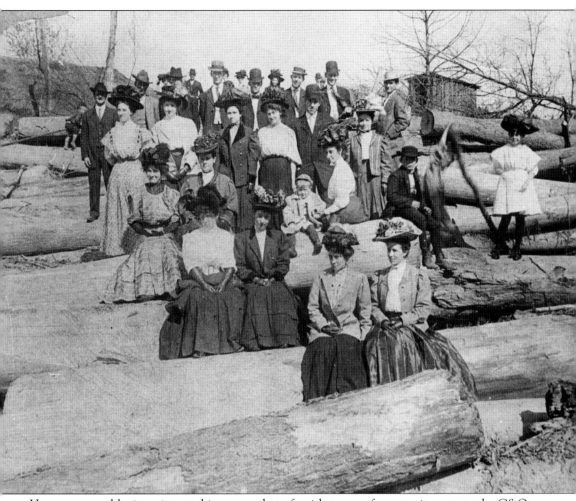

Here are several logjam sitters taking somewhat of a risk to pose for posterity next to the C&O Railway bridge in this undated photograph. The list of sitters reads like a Guyandotte city directory—there were Dugans, Hennens, Murphys, and Witherses in the mix. Logjams occurred frequently as timber men floated their products to market. (Courtesy of Mrs. Jack Hines.)

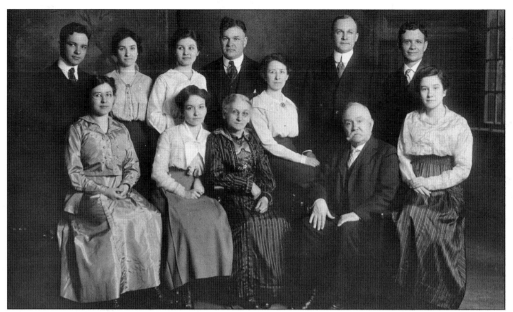

The Dugans were a prominent Guyandotte family for decades. Posing in 1917 are, from left to right, (seated) Charlotte Dugan Moore, Fannie Dugan Clark, ? Dugan, Lavenia Dugan Fisher, ? Dugan, and Elizabeth Dugan Steinbrecker; (standing) Irvin Dugan, Pearl Dugan Wheatley, Alice Dugan Johnson, Thomas Dugan, Walter Dugan, and Matt Dugan. (Courtesy of Mary Margaret Hennen Withers.)

Four Dugan brothers—from left to right, Thomas, Walter, Matt, and Irvin—pose at the Guyandotte Club on October 25, 1942. Matt was active in politics and served as everything from clerk to president of the Emmons-Hawkins Hardware Co. Irvin was a nationally celebrated artist for the *Huntington Advertiser*'s afternoon edition and the *Herald-Advertiser*'s Sunday edition for 30 years. (Courtesy of Mary Margaret Hennen Withers.)

The Diddles were another long-prominent family in Guyandotte. Here are the five Diddle brothers posing on the back steps of their home at 306 Depot Street in 1901. They are, from left to right, Kenneth, Nelwyn, Raymond (who is holding baby Merlyn), and Carl. The photograph was provided by Merlyn's son. (Courtesy of Merlyn Allen Diddle.)

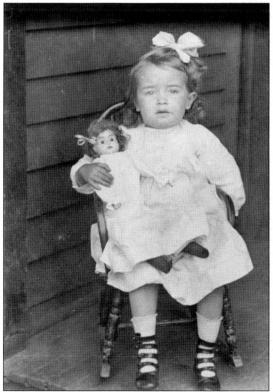

This is Helen Augusta Diddle at age two in 1915. A sister to the brothers in the photograph above, she holds her favorite doll and sits in her favorite chair. In addition to her future career as a Cabell County Schools employee, she will teach Sunday school at the Guyandotte Methodist Church. (Courtesy of Merlyn Allen Diddle.)

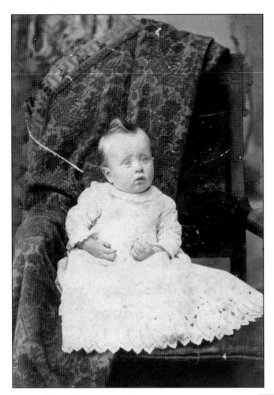

A 10-month-old Carl Diddle does not look too happy as his photograph is being taken in 1891 or 1892. After serving bravely in the Army during World War I, he will become a Huntington firefighter and help save many local families from utter disaster. (Courtesy of Merlyn Allen Diddle.)

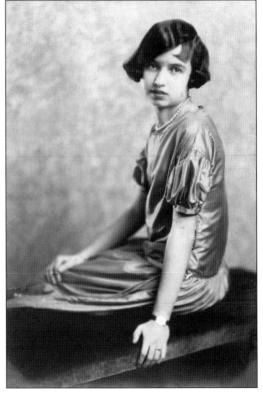

Helen Diddle poses at age 14 in 1926 or 1927. As the only sister of five older Diddle brothers, she likely put up with a good number of pranks plotted by her five bothersome brothers during her younger years. In spite of all that, she never stopped loving any of them. (Courtesy of Merlyn Allen Diddle.)

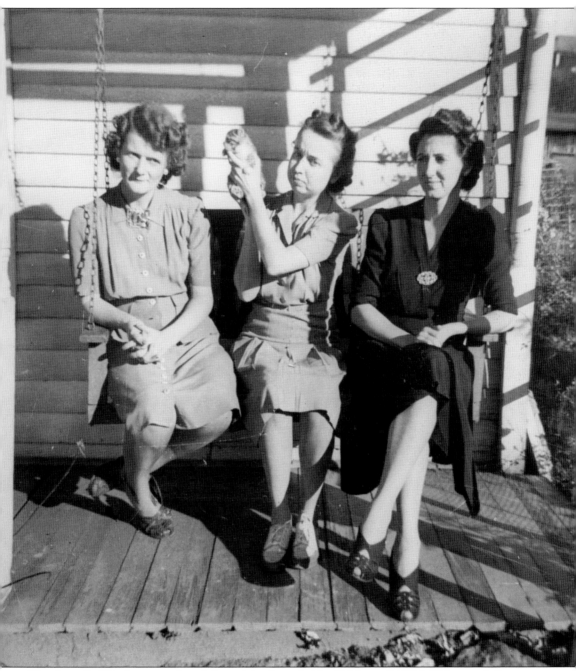

The three Diddles here are, from left to right, Lena (wife of Nelwyn Diddle), Helen, and Queen Anne (wife of Merlyn Diddle). They are enjoying a sunny day on Helen's porch at 306 Depot Street around 1940. Helen appears to be holding a kitten. She always loved cats—adopting strays, feeding them, and caring for them. (Courtesy of Merlyn Allen Diddle.)

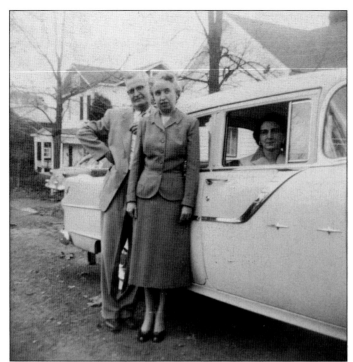

Siblings Nelwyn and Helen Diddle pose beside Nelwyn's automobile in front of Helen's home around 1950. That is Lena, Nelwyn's wife, sitting in the car. Nelwyn, a longtime pharmacist at Murphy's Drug Store, and his wife were likely concluding a visit to his family's old homestead. (Courtesy of Merlyn Allen Diddle.)

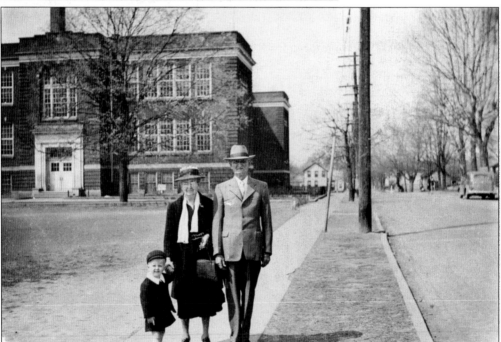

Augusta Fetty Diddle, Allen Lee Diddle, and their four-year-old grandson Merlyn Allen Diddle walk past Guyandotte Elementary School as they walk home from Guyandotte Methodist Episcopal Church–South on a sunny Easter Sunday on April 9, 1944. The author notes that a tall chain-link fence that surrounded the school building and playgrounds during his years there had not been installed yet. (Courtesy of Merlyn Allen Diddle.)

Allen Lee Diddle, a boilermaker who worked for the C&O Railway and helped found Huntington Boiler Works, died in 1946. When the body was being taken from his home to the church for the funeral, a Baltimore & Ohio (B&O) Railroad yard crew was blocking the Depot Street crossing. When crew members noticed the procession, they separated the train and held their caps over their hearts as it passed. (Courtesy of Merlyn Allen Diddle.)

Stephen and Fern Davis Saunders lived on Aaron Court, located in a hilly section of town above the B&O Railroad. He worked at the International Nickel Co. between 1921 and 1947. She gave birth to five sons and seven daughters in an eight-room house. The older kids helped entertain their younger siblings by putting them in bushel baskets and pushing them through the backyard. (Courtesy of Mary Ann Saunders.)

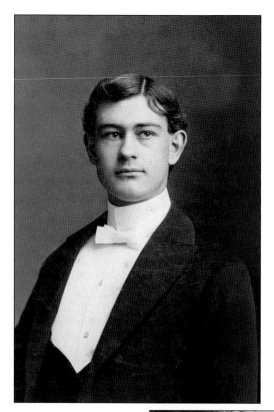

Dr. John Tauber was a dentist according to the note on the photograph, which is in Mary E. Poindexter Hennen's handwriting. The surviving family knows little about him but believes he was a brother of Maria Tauber Poindexter because her son J. Bernard Poindexter Sr. and grandson J. Bernard Poindexter Jr. were both dentists, and the family supposes they were inspired to follow in their uncle's (and great-uncle's) footsteps. (Courtesy of Mary E. Poindexter Hennen.)

Floyd S. Workman was a "gay young blade" when this picture was made shortly after the turn of the 20th century. He married Sallie Poindexter around 1904 and worked as a telegraph operator and dispatcher for the C&O Railway. He was a member of the company's rules committee when he retired in 1948. (Courtesy of Mary E. Poindexter Hennen.)

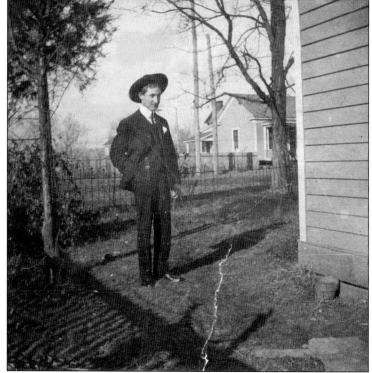

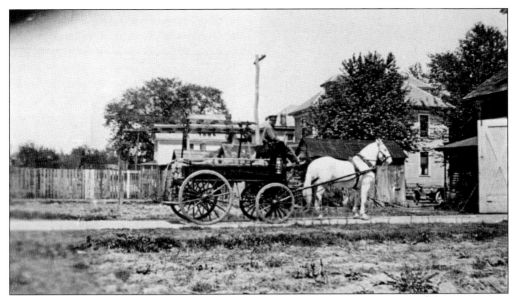

Firefighter Noah Johnson and a horse named Joe look like they are getting ready to give the Guyandotte fire wagon a bit of a workout around town. The station's commander, Capt. John E. Poindexter, often allowed his little niece Mary Margaret Hennen, who lived just up the block, to ride around the neighborhood on Joe. (Courtesy of Mary Margaret Hennen Withers.)

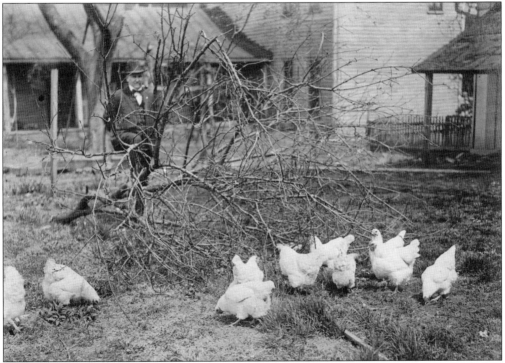

John C. Hennen keeps an eye on his chickens in his backyard at 313 Main Street in the late 1920s or early 1930s. Those were the days before Huntington outlawed such creatures being reared inside city limits. His daughter, Mary Margaret, has labeled the photograph in her scrapbook as "Papa & livestock." (Courtesy of Mary Margaret Hennen Withers.)

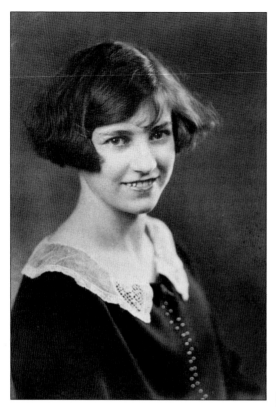

Mary Margaret Hennen is through with riding fire horses and such in this photograph, which appears to have been taken between 1924 and 1928. Those were her years at Marshall College (now University) in Huntington. A 47-year marriage, a son who will become an author, and a teaching career lie in her future. (Courtesy John Carlton Hennen Jr.)

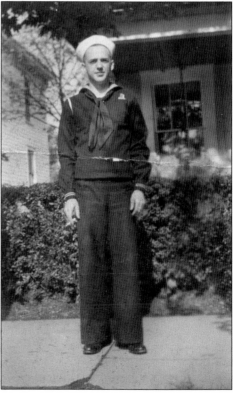

John Carlton Hennen Sr. looks like he is ready to join the Navy or perhaps enjoy some time on leave as he poses in front of his home at 313 Main Street. Equipped with a fine bass voice, he toured with the Navy's Blue Jacket Choir during his active duty years. (Courtesy of Mary Margaret Hennen Withers.)

Mary E. Poindexter poses on June 27, 1888, on her 17th birthday. She once wrote about her first three-mile trip from Guyandotte to Huntington in a buckboard when she was seven. "A trip to New York City many years later did not give me a greater thrill than that first visit to Huntington," she wrote. (Courtesy of John Carlton Hennen Jr.)

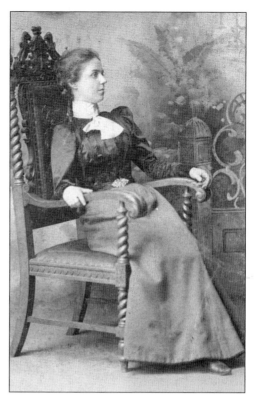

Sisters Sallie Poindexter Workman (left) and Mary E. Poindexter Hennen pose beside the Hennen home's front porch in the 1930s. It is obvious that Hennen loved to raise flowers. She always was eager to work in her flower garden, usually wearing a huge pink bonnet on sunny days. (Courtesy of Mary Margaret Hennen Withers.)

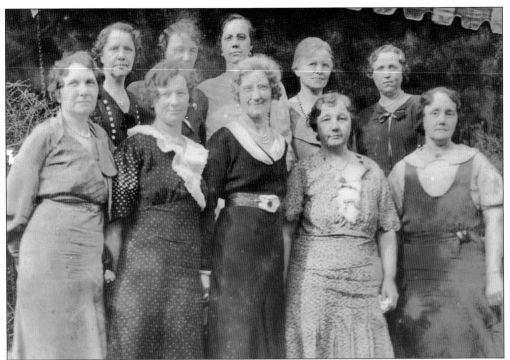

Several ladies pose during a Guyandotte High School class reunion in the 1930s. They are, from left to right, (first row) Bess Hayslip McMahon, Kate Mather, Bessie Church Boone, Georgia Scheneberg Crites, and Hazel Scheneberg Ohliner; (second row) Maud Stewart Phipps, Ona Burks Wells, unidentified, Charlotte Dugan Moore, and Sallie Poindexter Workman. (Courtesy of Mary Margaret Hennen Withers.)

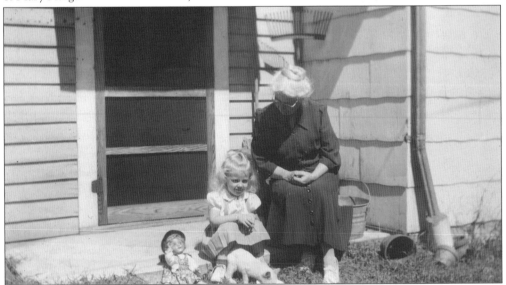

"Grannie" Mary E. Poindexter Hennen, her familiar topknot clearly in view, visits with granddaughter Beverly Gwinn Hennen and a cat named Whitey on her back porch at 313 Main Street around 1943. Grannie was a favorite with her four grandchildren, with all the cookies she baked and the bowls she offered to be licked clean. (Courtesy of John Carlton Hennen Jr.)

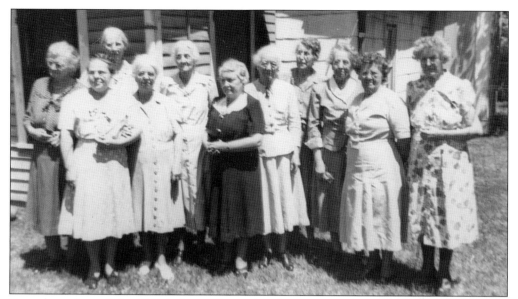

Several members of Mary E. Poindexter Hennen's quilting group at Guyandotte Methodist Church gather with her in her backyard on June 27, 1949, to help her celebrate her 78th birthday. Several members of Mary E. Poindexter Hennen's quilting group at Guyandotte Methodist Church gather with her in her back yard on June 27, 1949, to help her celebrate her 78th birthday. They are, from left to right, unidentified, Ida Kirby, Eppa Corrine Debar (wife of pastor W.A. Debar), Mary E. Poindexter Hennen (the author's maternal grandmother), two unidentified women, Leona Lawwill, Stella Everett, two unidentified women, and Ann Wilson. (Courtesy of Mary Margaret Hennen Withers.).

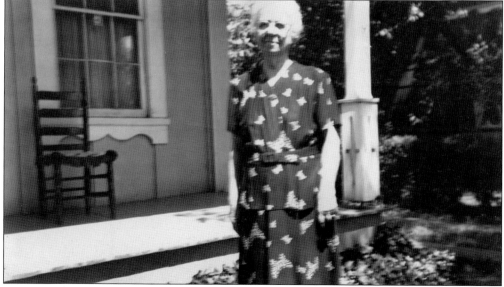

Mary E. Poindexter Hennen poses in front of her home on May 28, 1953. There is ivy bordering the porch. She considered buying a sprig of ivy while visiting Thomas Jefferson's Monticello near Charlottesville, Virginia, in the 1930s but considered the price too steep. Upon leaving, she conned a gardener out of a free piece. The former president's plant still garnishes Guyandotte today. (Courtesy of Mary Margaret Hennen Withers.)

Mary E. Poindexter Hennen poses in front of her whatnots in 1956. The intricately designed set of shelves, crafted long ago by a Guyandotte carpenter, stands today in the home of one of her great-granddaughters, providing a nifty place for her cat Jessie to take an afternoon nap. (Courtesy of the *Herald-Dispatch*.)

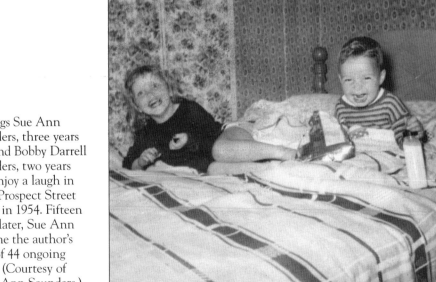

Siblings Sue Ann Saunders, three years old, and Bobby Darrell Saunders, two years old, enjoy a laugh in their Prospect Street home in 1954. Fifteen years later, Sue Ann became the author's wife of 44 ongoing years. (Courtesy of Mary Ann Saunders.)

Bethel and Mary Wilcox pose between the home of Bethel's dad, Harry, at 222 Buffington Street (left) and their own home at 224 Buffington Street in 1939. Bethel holds their one-year-old son, Damon. (Courtesy of Damon Wilcox.)

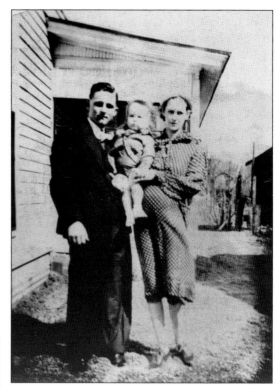

This is Mary Wilcox and her newborn daughter Janis beside the home of Mary's in-laws at 222 Buffington Street in 1940. Janis would eventually marry a Freewill Baptist preacher who would ultimately teach at a Freewill Baptist College in Nashville. (Courtesy of Damon Wilcox.)

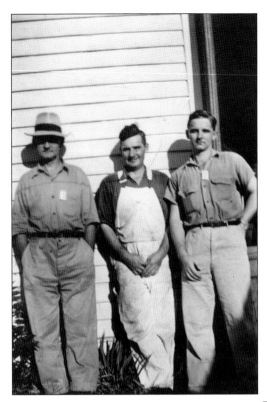

Three Wilcoxes appear in this image. From left to right, Harry, Clayton (Harry's brother), and Bethel (Harry's son) pose at Harry's home on 222 Buffington Street in the early 1940s. Clayton was a mechanic at C&O's Huntington shop. Harry and Bethel, wearing identification badges, worked at the International Nickel Co. Bethel was excused from military duty because the plant produced boat shafts and cannon barrels essential for the Allied war effort. (Courtesy of Damon Wilcox.)

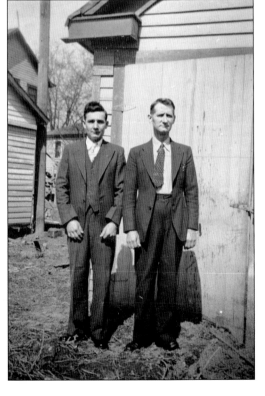

Clayton Wilcox (left) and his father, Harry Wilcox, pose in front of dad's garage at 222 Buffington Street in the 1940s. Descendents have no idea why they are dressed up, but they assume that since Clayton is a part-time Freewill Baptist preacher, the two may be on their way to a worship service or revival. (Courtesy of Damon Wilcox.)

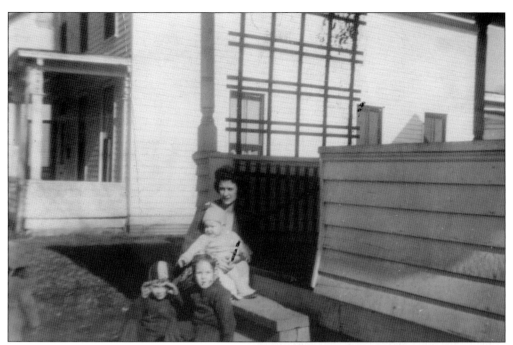

Mary Wilcox poses with her children Elizabeth, two years old; Janis, four years old; and Damon, also four years old, on the front steps of their home at 224 Buffington Street in 1944. Peter Cline Buffington, a son of William Buffington and the first mayor of Huntington, built Mary's father-in-law Harry Wilcox's home, which is visible in the in the background at 222 Buffington Street in 1859. (Courtesy of Damon Wilcox.)

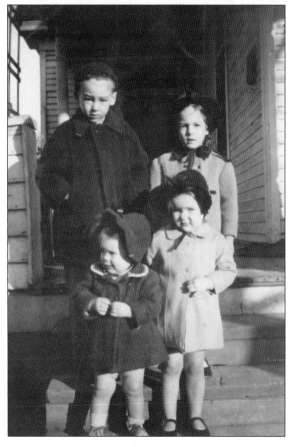

The children of Bethel and Mary Wilcox pose in the front steps of their home at 224 Buffington Street in 1946. Starting at top left and going clockwise, they are Damon, seven; Janis, five; Betty, three; and Linda, one. Bethel bought the home in 1941 or 1942 so the family could be next door to his parents, thus acquiring a nearby source of willing babysitters. (Courtesy of Damon Wilcox.)

Following the pose captured by their mother at the bottom of the previous page, Damon Wilcox tries his hand with the camera. Sister Janis has tired of posing and is going into the house, leaving only Linda (left) and Betty. It is always difficult to persuade small children to hold still for very long. (Courtesy of Damon Wilcox.)

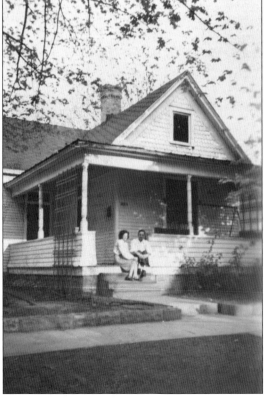

The kids are likely at school or taking naps as parents Bethel and Mary Wilcox enjoy a quiet moment together on the front steps of their home at 224 Buffington Street in the late 1940s. Between Bethel's work at the International Nickel Co. and the couple having four children, such peaceful times must have been rare indeed. (Courtesy of Damon Wilcox.)

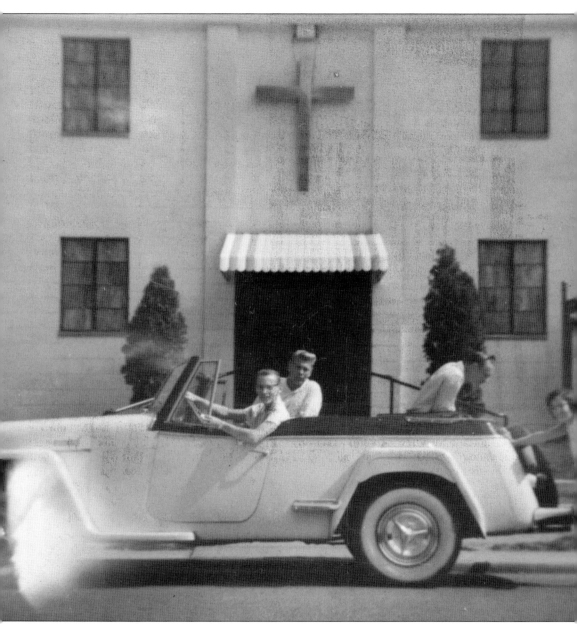

With owner Darrell Anderson at the wheel in 1959, Phyllis Kirk pushed—by herself—an old Jeep Sportster in front of Thomas Memorial Freewill Baptist Church on Buffington Street as friend Larry Albright (up front) and Darrell's twin, Sherill (backseat) watch. "That thing wouldn't run half the time," Phyllis recalls. (Courtesy of Damon Wilcox.)

It is 1948, and the family has grown and moved to 104 Sixth Avenue. Phyllis (left) is eight years old; Peggy, beside her, is five. In front of Phyllis is two-year-old Michael Adkins, whose family was renting a room next door. A third sister named Patty, three, is pouting in the hedge at right, dressed only in her underwear. (Courtesy of Phyllis Kirk Wilcox.)

A year later, all four Kirk daughters pose across the street from their home at 104 Sixth Avenue. Delores (also called "Sally"), 13 years old, and Phyllis, 9, are in back; Peggy, 6, and Patty, 4, are in front. Phyllis is wearing clown makeup, so the circus must be in town. (Courtesy of Phyllis Kirk Wilcox.)

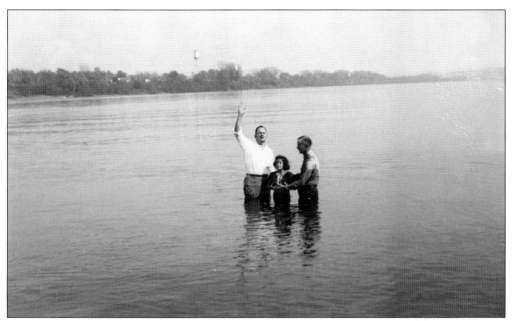

It is January 1949, and nine-year-old Phyllis is being baptized in the Ohio River at the foot of Buffington Street. Doing the honors are the Reverend Carl Vallance (left), pastor of Thomas Memorial Freewill Baptist Church, and E.B. Legg. "Oh my gosh, that water was cold," Phyllis recalls. (Courtesy of Phyllis Kirk Wilcox.)

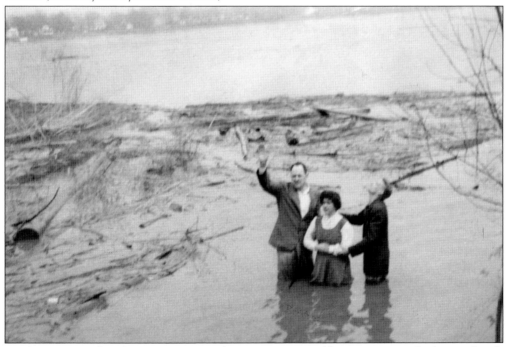

It's the same Sunday in January 1949, and now it's six-year-old Peggy's turn to be baptized with Dorman Sargent (right), Thomas Memorial's song leader, assisting Brother Vallance this time. The Ohio River's water level is high and has picked up some debris off the bank that has floated into the picture. (Courtesy of Phyllis Kirk Wilcox.)

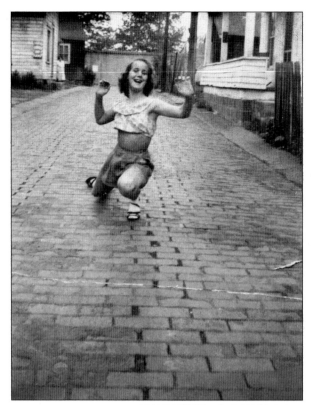

Delores Kirk prances in the street in front of her home at 104 Sixth Avenue in 1939 or 1940. "She was a wannabe cheerleader," her sister Phyllis claims. Elihu Adkins's barbershop is on the left in the background, as is the flood wall protecting the town from the occasional ravages of the Guyandotte River. (Courtesy of Phyllis Kirk Wilcox.)

It is Easter Sunday in this April 9, 1950 photograph. Kirk sisters Peggy, seven years old, and Patty, five, show off their Easter baskets after coming home from church. Before the photograph was taken, Peggy insisted on changing her clothes. "She hated dresses, and still does," says her sister Phyllis. "She is the tomboy of the family." (Courtesy of Phyllis Kirk Wilcox.)

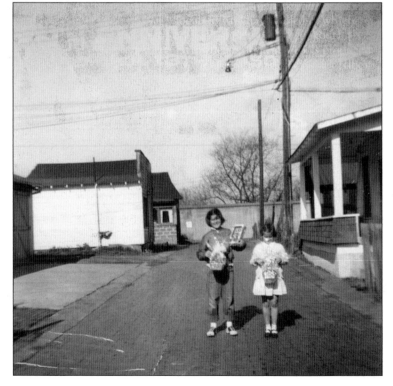

Here is Peggy in 1950, wearing a jumper and a sweater and holding a basketball. She ended up becoming a gym teacher and coach at a Catholic high school in Northern Virginia. She retired as a vice principal and moved to Leland, North Carolina. (Courtesy of Phyllis Kirk Wilcox.)

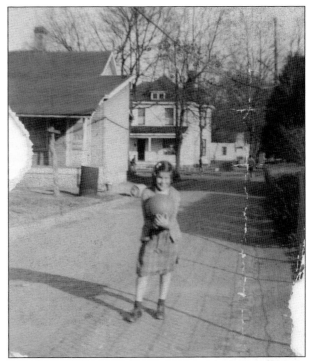

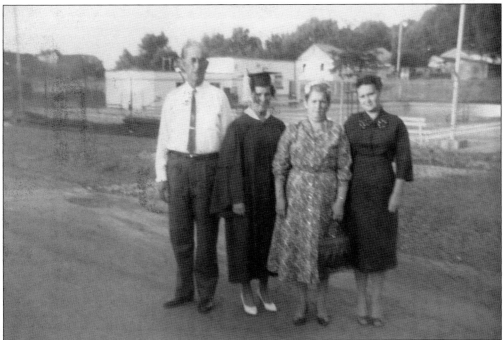

In 1949, Acie Kirk died of tuberculosis at 32 years old. His wife, Ruby, remarried 10 years later to John Henry "Pop" Bays. Pop and Ruby pose with Peggy (second from left) and Patty (far right). In this June 1960 photograph, Peggy is graduating from Huntington East High School. The image was captured at 511 Everett Street with the Guyandotte Pool in the background. (Courtesy of Phyllis Kirk Wilcox.)

Damon and Phyllis Kirk Wilcox pose with their children, Jonathan Patrick, seven years old, and Heather Dawn, four, in front of Phyllis's mother's home in 1974. J.P. joined the Navy and lives on Ford Island in Honolulu as of this writing, whereas Heather Dawn teaches kindergarten in Pendleton, Indiana. The Guyandotte United Methodist Church is on the right in the background. (Courtesy of Phyllis Kirk Wilcox.)

Twice widowed, Ruby Kirk Bays has moved back to 104 Sixth Avenue. She is older in this photograph, but she was still able to make 70 quarts of apple butter in a big copper kettle every October. She is ready to scoop up a sample, dump it in a saucer, and tip the saucer on its side. If the sample runs off, it is not ready. (Courtesy of Phyllis Kirk Wilcox.)

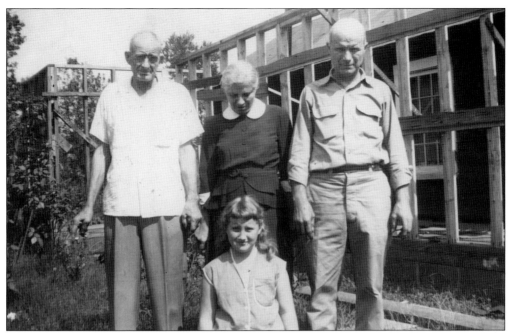

Nellie Moore, who is standing between brothers Guy (left) and Harry and in front of Harry's daughter Marlene in the 1950s, was a skilled saleswoman. She once sold dishrags for her Home Builders Sunday school class at Guyandotte Methodist Church for 30¢ apiece or three for a dollar. Most of her customers took three for a dollar, thinking they were getting a bargain. (Courtesy of Bill and Betty Moore.)

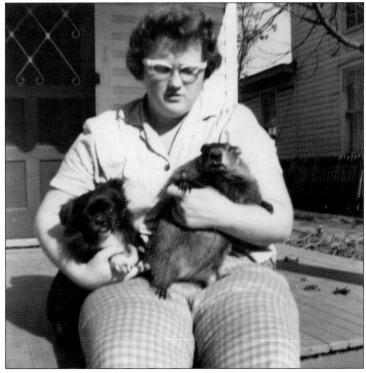

It is November 1961, and 17-year-old Marlene Moore poses with her pets on the front porch of the family home at 606 Fifth Avenue. She holds her dog named Rags in her right hand and her groundhog named Squeaky in her left. Squeaky was just as much a part of the family as Rags was, sleeping at night behind a living room couch. (Courtesy of Bill and Betty Moore.)

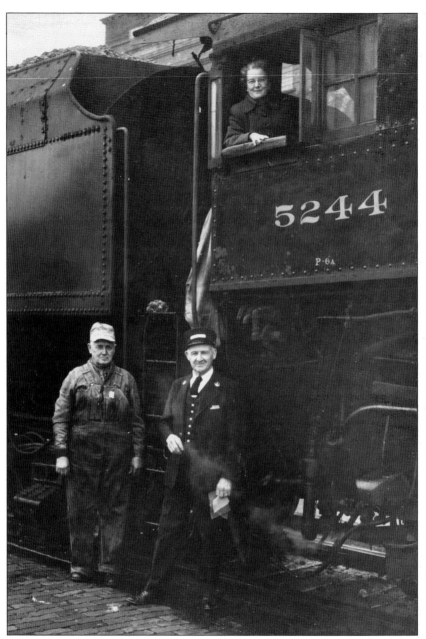

Contrary to appearances, this train is not being operated by a female engineer. It is Thursday, January 31, 1957, and Bea Lawwill is a clerk in the district freight agent's office on the second floor of Huntington's B&O station. Bea lives in Guyandotte—3.4 miles eastward—with her mother, Leona Lawwill. They go to church there; their hearts are there. This Kenova–Wheeling, West Virginia, passenger train no. 72 is about to make its final run through Guyandotte, and Bea wants to sit in the engineer's seat before the train chugs through her beloved neighborhood for the last time. Standing on the station platform are the real engineer, Marvin J. "Daddy" Reed (left) and conductor Herbert W. Sammons. Both men will retire within a year, but Bea will continue to work upstairs, undoubtedly pausing to remember how things once were. (Courtesy of Charles Lemley.)

# *Three*

# HOME IS WHERE THE HEART IS

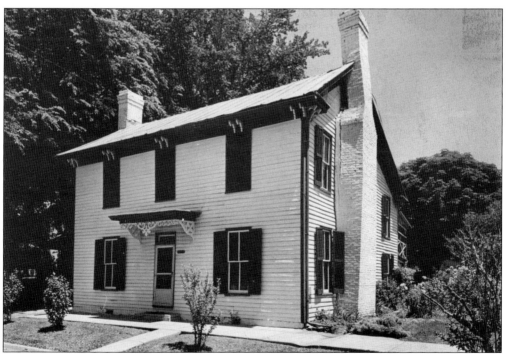

River tradesman James Gallaher of Gallipolis, Ohio, floated this home in sections down the Ohio to Guyandotte by flatboat in 1810 and reassembled it at 234 Guyan Street. Thomas Carroll, an Irish carpenter and stonemason, bought it in 1855, and he and his widow operated it as the Carroll House. The home has been restored, and tours are available by appointment. (Courtesy of the *Herald-Dispatch*.)

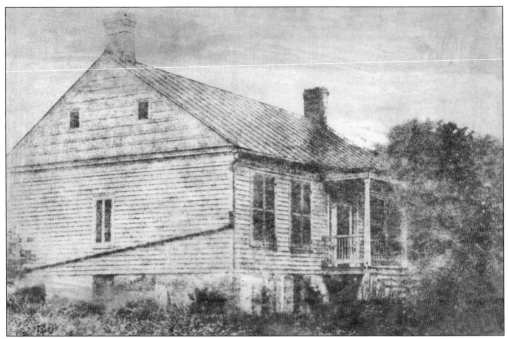

Victor LaTulle, a naturalized Frenchman, grocer, and real estate investor in Guyandotte, built this home at 268 Guyan Street shortly after 1849. Its original architecture was French Colonial, with a kitchen located in the basement. Today, the structure is home to a Huntington city councilman. (Courtesy of Special Collections, Marshall University.)

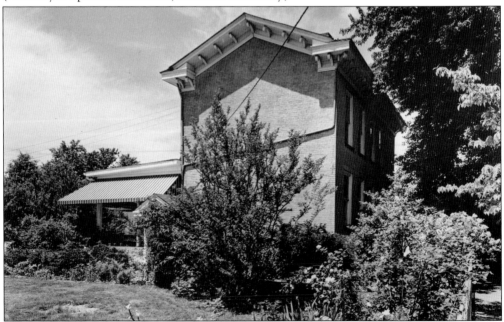

This colonial 14-room brick home was built at 101 Main Street in 1816 by Henry and Charles Lewis. Thomas and Mary Buffington lived there in the 1850s, and Confederate general Albert Gallatin Jenkins used it as his local headquarters during the Civil War. The home sits on a foundation of large native cut stones. (Courtesy of the *Herald-Dispatch*.)

John M. Beale and his wife built the stately Victorian home above at 102 Main Street. By the 1970s, the home had lost its wraparound front porch. Beale (below, left) was a Guyandotte merchant who helped organize a wholesale grocery in Huntington in 1890. He served as president of the Guyandotte Centennial Commission in 1910 and was a member of the last Guyandotte Town Council when it met on April 11, 1911, to canvass a vote of the people to allow the town to become a part of Huntington. Finding 260 votes for and 70 opposed, the council declared Guyandotte to be part of Huntington and adjourned sine die. Beale and his wife (below, right) were active in the Guyandotte Methodist Episcopal Church–South. (Above, courtesy of the *Herald-Dispatch*; below, both courtesy of Special Collections, Marshall University.)

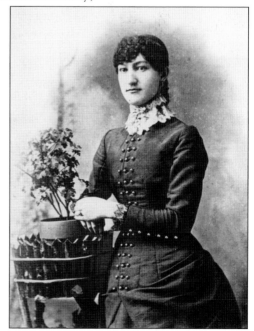

William C. Dusenberry, an early Cabell County Schools superintendent, came to Guyandotte before the Civil War and built this brick home at 211 Main Street. Later, a Poindexter family owned it. The author's great-aunt Sallie Poindexter Workman was born in the home in 1883. It was torn down in the 1960s to make way for a parking lot. (Courtesy of Bob Withers.)

Burgess Stewart built this colonial frame home at 224 Main Street in about 1846. Stewart, a trustee of the Guyandotte Methodist Episcopal Church–South, and his family were active in several Guyandotte businesses, including the Guyandotte Woolen Mills. The home, with ornate gingerbread edging on its roofs, remained in his family until 1945. The Veterans of Foreign Wars subsequently purchased the property and razed the structure. (Courtesy of the *Herald-Dispatch*.)

William Stone built this brick home at 232 Main Street in 1823. During the Civil War, a prisoner was held under arrest in the house, and a bullet hole made during the 1861 Battle of Guyandotte is still visible in the front door. During the cholera epidemic of 1873, the building was used as an infirmary. (Courtesy of Bob Withers.)

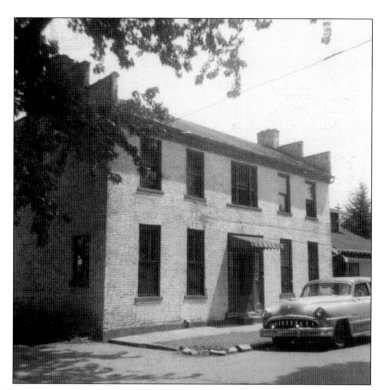

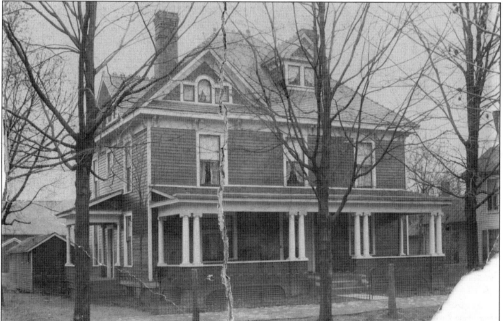

This home, located at 302 Main Street, was built in 1841. Its second owner, William Henry Wilson, made substantial changes in it around 1910, including the replacement of a flat roof, but the original wide floorboards remain intact. Longtime resident Elizabeth Garrette, one of Wilson's descendants, was born in the house in about 1905 and lived there until 1984. (Courtesy of Mary Margaret Hennen Withers.)

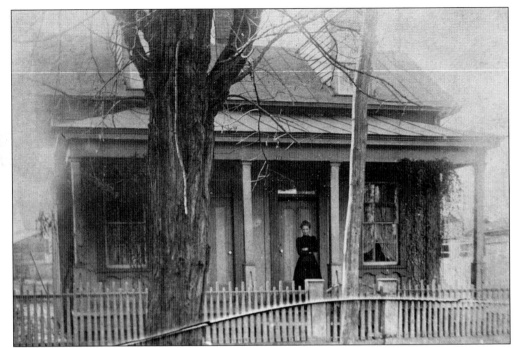

Charlotte Swann Workman poses on the front porch of 313 Main Street in 1907. The home is thought to have existed in 1836 because courthouse records show that the half acre upon which the house sits was sold in that year for $200 at the same time nine acres of corn sold for $45. (Courtesy of the *Herald-Dispatch*.)

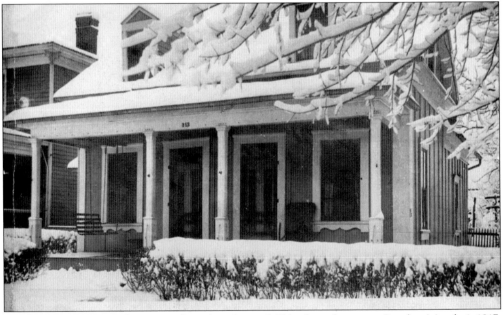

The home at 313 Main Street stands under a beautiful blanket of snow on Sunday, March 4, 1917. A doctor owned the home during the Civil War, which may explain why it was not burned during the Battle of Guyandotte. Interestingly, there are two front doors. Local folks believe that the doctor lived in one side and had his office in the other. (Courtesy of John Carlton Hennen Jr.)

Druggist James Murphy built this Victorian home at 401 Main Street in the 1880s. Chiropractor William F. Nease and his family later occupied the home, and the Guyandotte Woman's Club occupied it after that. Sadly, the old home is vacant today and deteriorating badly. (Courtesy of Special Collections, Marshall University.)

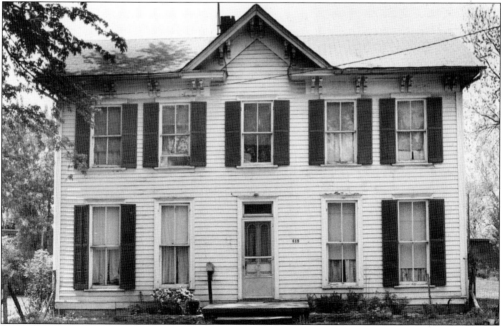

This was the home of Zachary Taylor Wellington, who was born in 1847 and worked as a carpenter, county assessor, deputy sheriff, city councilman, and for many years, was a Guyandotte postmaster. With the addition of a nice wide porch, the house serves today as a rental property. (Courtesy of the *Herald-Dispatch*.)

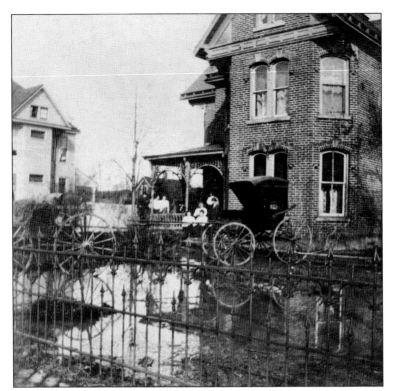

Bernhardt Tauber built this home at 418 Main Street in 1886, patterned on a prototype from his native Germany. It was the first Cabell County home to have a bathtub—a wooden structure overlaid with copper. There is high water in the front yard. The home and two others were razed long ago to make room for an industrial credit union. (Courtesy of J. Bernard Poindexter.)

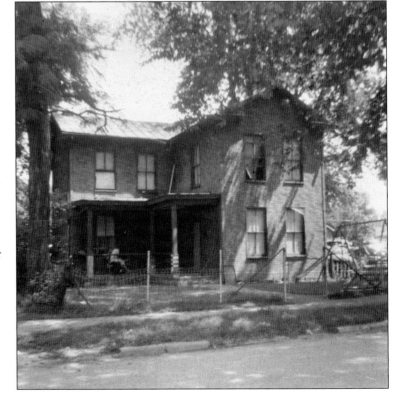

A family of Poindexters occupied this home at 420 Main Street in the late 19th and early 20th centuries. The author's grandmother recorded the arrival of the first Ohio River Railroad train to pass beside the home in 1892, and his mother was born there in 1906. (Courtesy of Bob Withers.)

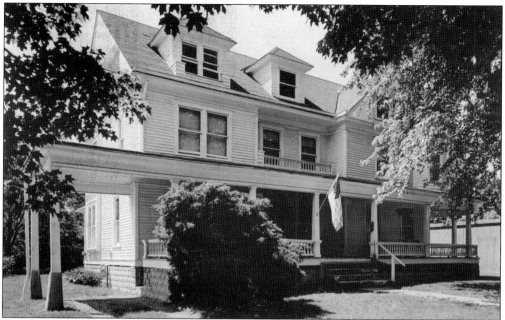

Lumberman Will Kahler built this large frame Victorian home. The woodwork in the parlor is cherry, and the parlor floors are maple. Most of the rest of the woodwork is oak. The building features an elaborate oak stairway in the entrance hall and cut-and-leaded glass around the front door. The home, owned today by Ruth Christ Sullivan, was moved inland to make room for the Ohio River flood wall. (Courtesy of the *Herald-Dispatch*.)

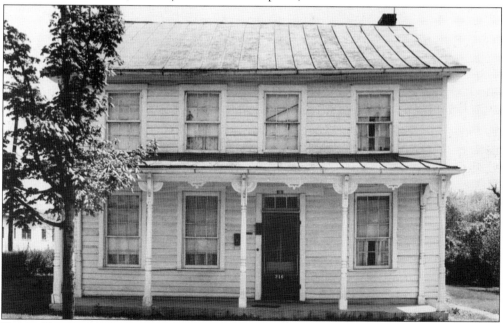

Henry Clay Everett built this home at 216 Richmond Street in 1855 and lived in it until the beginning of the Civil War. The Dawkins family moved in years later, and R. Jack Dawkins served as the Guyandotte Methodist Church's Sunday school superintendent for so long that his cubbyhole next to the sanctuary is still referred to as "Jack's office." (Courtesy of the *Herald-Dispatch*.)

After the Civil War was over, Henry Clay Everett, a prominent miller and grocer, returned to Guyandotte and was so disturbed by the town's wreckage that he moved his family to Texas. This photograph was probably taken in Texas, but it is included here because he was a native of Guyandotte. A much newer home occupies the property today. (Courtesy of Special Collections, Marshall University.)

Jacob Hiltbrunner, a tanner, built the structure below at 307 Water Street in 1855 to serve as a hotel. William "Crawley" Smith bought it in 1867 and continued using it as an inn. It was used as a hospital during the Civil War. It was moved back a little in 1943 to make room for the Ohio River flood wall. (Courtesy of Special Collections, Marshall University.)

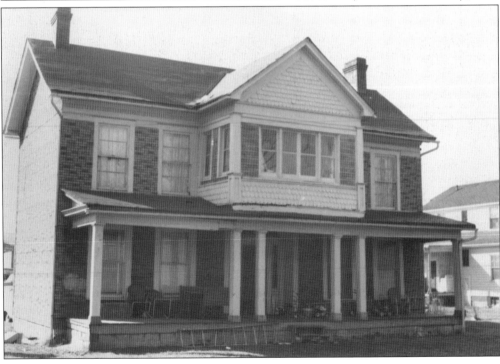

# *Four*

# THE STORES ARE OPEN

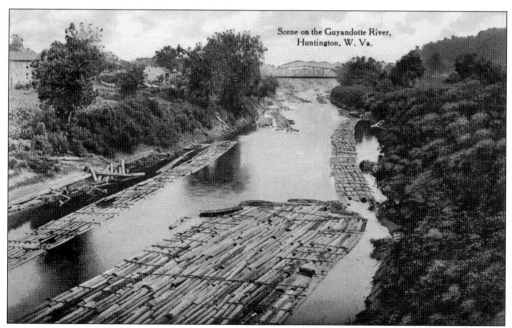

One of Guyandotte's earliest businesses was timbering. Before area railroads were developed, lumbermen floated log rafts from Logan and Lincoln counties down the Guyandotte River to the Ohio—a particularly hazardous occupation, especially when slippery ice formed on the water's surface and the logs in winter. (Courtesy of Mary E. Poindexter Hennen.)

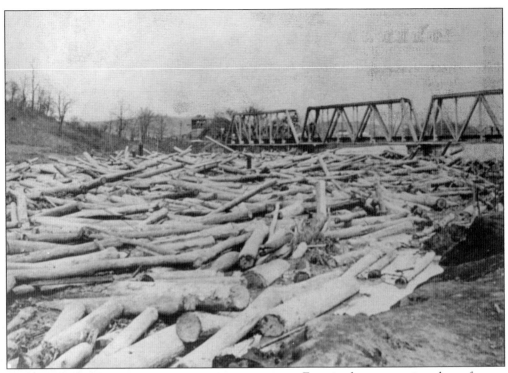

Even in the summertime, log rafts were dangerous. In this photograph, a logjam in the Guyandotte River threatens the C&O Railway bridge at Guyandotte. DK Cabin, a telegraph office where orders were delivered to train crews, is visible on the west bank of the river. (Courtesy of Special Collections, Marshall University.)

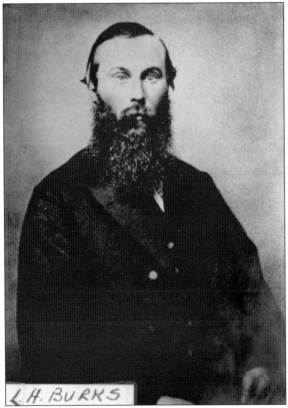

L.H. BURKS

Timber man Lewis H. Burks lived on a farm west of the mouth of the Guyandotte River, the watery highway he used for the transport of his logs. For a while, when he was an agent for the Cole Crane & Co., he occupied an office in George S. Page and Henry Clay Everett's grocery store. (Courtesy of Special Collections, Marshall University.)

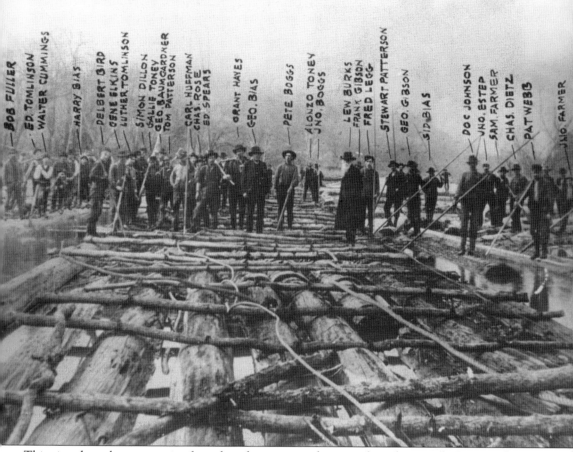

This view shows loggers pausing from their dangerous work to pose for a photograph. Someone has kindly identified each of the men. The coming of the railroads is near; if they survive this trip, they will have to find another line of work. (Courtesy of Special Collections, Marshall University.)

The name of this Guyandotte store is not readable, but one thing is clear: like Murphy's Drug Store, it was a gathering place for loafers who wished to congregate, visit with each other, and solve the world's problems. (Courtesy of Mary Margaret Hennen Withers.)

James Murphy was the patriarch of Murphy's Drug Store for decades. He was active in politics, and served as one of Guyandotte's last councilmen. He also contributed to the town's centennial in 1910 by mustering a cavalcade of ladies dressed in white with red sashes who that horseback in the centennial parade—and got drenched in a sudden downpour. (Courtesy of Special Collections, Marshall University.)

Scott Barnett, owner of Murphy's Store in more recent years, watches as Mary Margaret Hennen Withers (center) and Elizabeth Garrette check copies of a newspaper advertising Old Guyandotte Days, scheduled for July 4–6, 1975. The Guyandotte Association for Improvement and Preservation sponsored the event. (Courtesy of the *Herald-Dispatch*.)

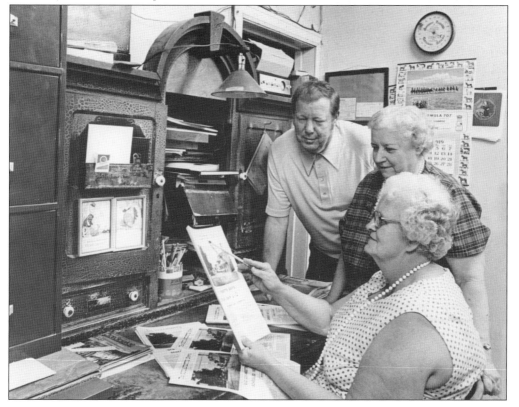

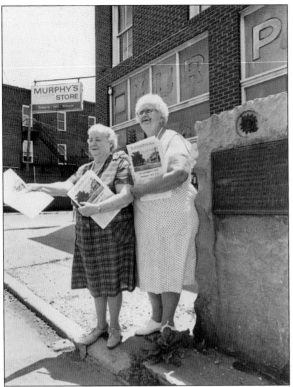

A most unusual pair of newspaper carriers—Mary Margaret Hennen Withers (left) and Elizabeth Garrette—hawk free copies of the *Guyandotte News* in front of Murphy's in the summer of 1975. Note that Murphy's Store is no longer Murphy's Drug Store since Scott Barnett lost his pharmacist. (Courtesy of the *Herald-Dispatch.*)

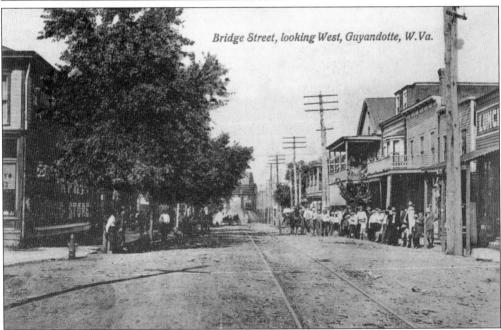

This postcard view looks west from the corner of Bridge and Main Streets in 1908. The streets are not yet paved, but the streetcar line from downtown Huntington has been extended from the west bank of the Guyandotte River across the new bridge and on to Buffington Street, two more blocks eastward. (Courtesy of Bob Withers.)

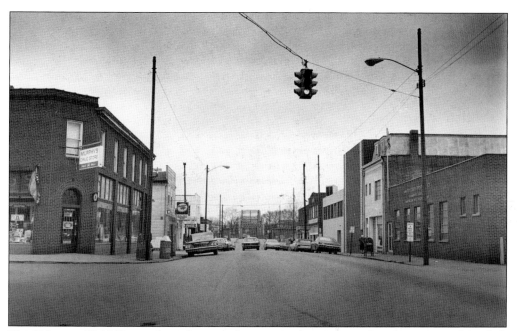

This February 27, 1969, view faces the same direction as the image on the previous page. Murphy's Store has been bricked over, the trees are gone, and the streetcar track has been paved over. The brick building on the right is the Guyandotte branch of the Huntington Post Office. (Courtesy of the *Herald-Dispatch*.)

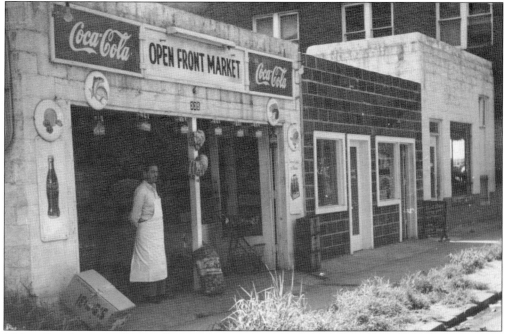

Melvin Booth poses in front of his new Open Front Market at 335 Bridge Street in 1947. Two of his brothers, Arnold and Homer, also operated grocery stores within four blocks of each other. Arnold's store saw a lot of young customers; it was across from Guyandotte Elementary School on Fifth Avenue. Melvin also skillfully painted scenes as a hobby. (Courtesy of Lisa Lafon.)

Elza C. Moore & Sons Hardware opened at 303 Bridge Street in 1947 after Moore bought out M.E. Blake. Moore expanded his business when he bought Dolous Blake's grocery at 301 Bridge Street from Blake's widow. Blake's niece ended up marrying Moore's son. The store is partially hidden by a sign at Dan Ferris's barbershop, which the jolly cutup referred to as the Golden Mug. (Courtesy of the *Herald-Dispatch*.)

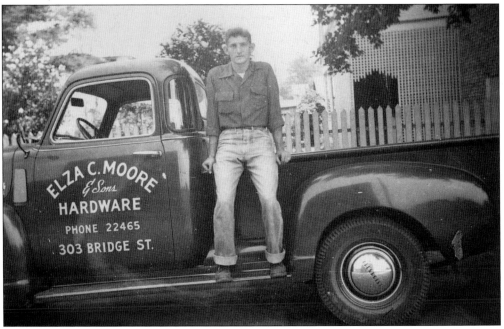

Shirley Blake, the first clerk hired for work at Elza C. Moore & Sons Hardware, poses on the running board of the company's first delivery truck in 1949. A natural gas explosion in a neighboring appliance store in 2003 also destroyed the hardware buildings, but the business thrives today in a replacement building and with a new owner. (Courtesy of Spencer Moore.)

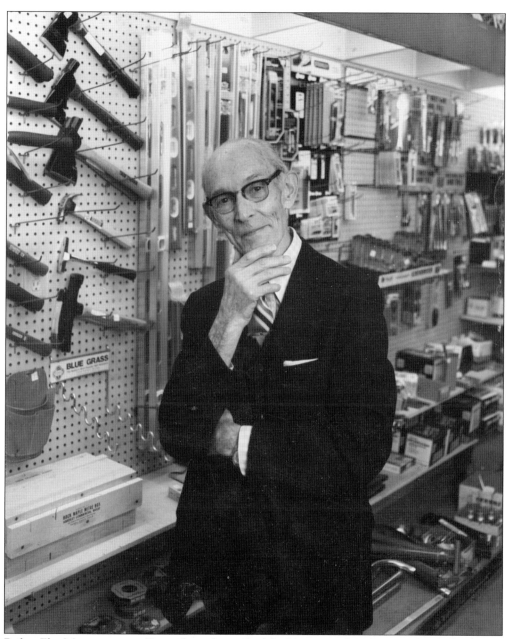

Before Elza Moore came to Guyandotte, he worked for 20 years at C.M. Love & Co. in downtown Huntington and several more years in his wire fabrication business. He stayed on the job at his hardware store well into his 90s, assisted by his sons Spencer and Richard. "I will be here as long as I am physically and mentally able of being here," he told a newspaper reporter on his 83rd birthday in 1988. "I have no intention of retiring because, to me, this is retirement. I don't care about sports or traveling; this is what I love to do." The reporter also quoted Alicia Meadows, a clerk at the store, in the article. "He reaches out to you and makes you feel good, whether he feels good or not," she said. "It brings tears to my eyes when I think of all the wonderful things he has done for other people. I just can't say enough about him because he's terrific." (Courtesy of Spencer Moore.)

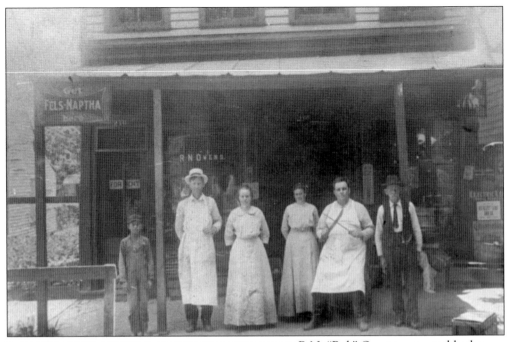

R.N. "Bob" Owens, presumably the fellow with the crossed butcher knives, poses with his staff and members of his family in front of his Guyandotte grocery store. Signs advertise Fels-Naptha and Chesterfield cigarettes. It looks like he has an upstairs apartment for rent, too. At one time, Owens served as town marshal. (Courtesy of the *Herald-Dispatch*.)

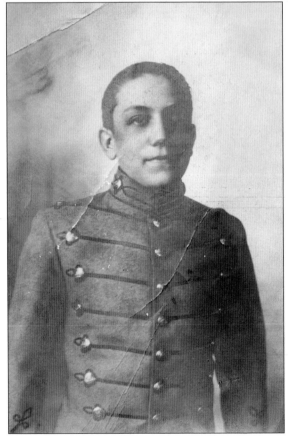

The lad at left in the image above may be pictured here, a little older and apparently wearing some kind of band uniform. He is Frank Owens, son of storekeeper R.N. "Bob" Owens, and one of young John Carlton Hennen Sr.'s longtime-favorite playmates. (Courtesy of Mary Margaret Hennen Withers.)

Mary C. Lyons, longtime storekeeper in Guyandotte, poses in front of her home at 315 Main Street in this undated photograph. Her father, Julius Freutel, sold John and Mary Poindexter Hennen the old home next door, 313 Main Street, on January 15, 1912, for $1,650. The down payment was only $300. (Courtesy of Mary Margaret Hennen Withers.)

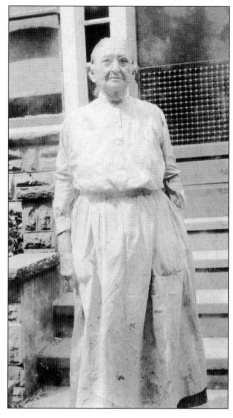

This John B. Hite was a son of the John B. Hite who was a tanner and helped incorporate the Guyandotte Bridge Co. in 1848. The company opened the town's first bridge, a suspension span supported by stone pillars, in 1852. He was long considered one of Guyandotte's "first citizens." The young Hite served on Guyandotte's council and as a marshal and treasurer. (Courtesy of Mary Margaret Hennen Withers.)

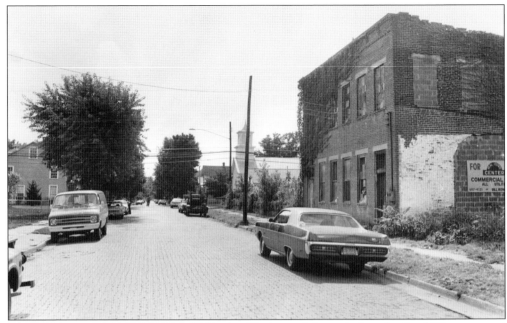

This building, constructed in the 200 block of Richmond Street before the Civil War, was used in the late 18th century as an outlet store for the Guyandotte Woolen Mills. Later, it was a cigar factory; its earliest use is unknown. The First Guyandotte Baptist Church stands in the background. (Courtesy of the *Herald-Dispatch*.)

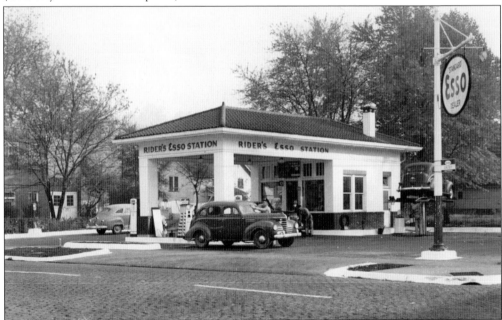

Raymond Rider's Esso Station, situated on the southeast corner of Bridge and Buffington Streets, is quite busy in the late 1940s. The drivers of a Dodge, a Chevy, and a Plymouth (the latter mostly hidden by the Dodge) are getting some snappy service. A newer Exxon service station and convenience store occupies the spot today. Currently, Rider's son Wilfred operates a service station a block away. (Courtesy of Wilfred Rider.)

# *Five*

# CHURCHES, CONGREGATIONS, AND CHOIRS

The Guyandotte Methodist Episcopal Church–South at 305 Main Street stands ready to welcome worshipers in 1905. Note that the street is not yet paved. The congregation has just added a lecture room, vestibule, and steeple financed with money received from the federal government because of damages incurred during the Civil War. (Courtesy of Mary Margaret Hennen Withers.)

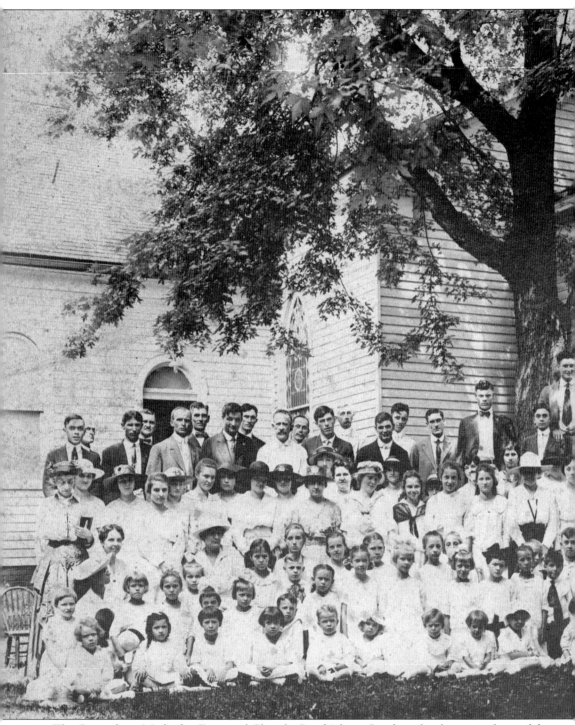

The Guyandotte Methodist Episcopal Church–South's large Sunday school poses in front of the sanctuary on Sunday, July 29, 1917. The congregation was formed in 1804, making it the oldest in the area that became Cabell County in 1809. The building itself, which still welcomes worshipers, was completed in 1870 on the same foundation of a brick sanctuary that either was burned or fell

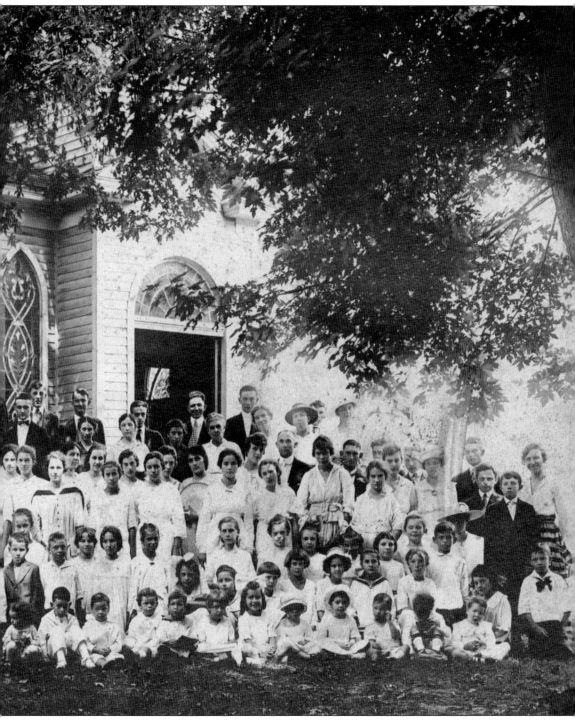

into ruins during the Civil War. With money received from the federal government because of the wartime loss, the lecture room at left and the vestibule were added in 1905; a year later, the vestibule received stained-glass windows. (Courtesy of Mary Margaret Hennen Withers.)

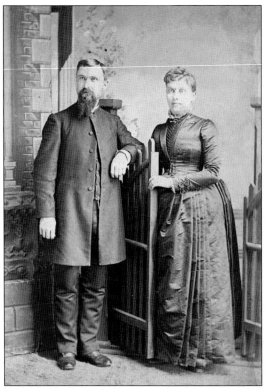

Rev. Elliott W. Reynolds and his wife served the Guyandotte Methodist Episcopal Church–South at 305 Main Street in 1890 and 1891. The state bishop appointed Methodist pastors, and in those days, their appointments did not last very long at any one church. During the church's first century, 91 pastors served there. (Courtesy of Mary Margaret Hennen Withers.)

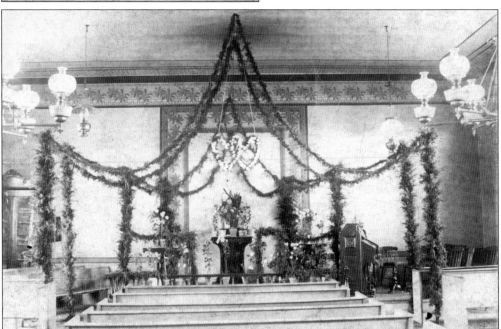

The interior of the Guyandotte Methodist Episcopal Church–South is decorated for the wedding of Will Kahler and Garnet Page on November 14, 1896. The gas lights and pump organ will give way to electric replacements in following years, and the original pews will have to be replaced after the 1913 flood. (Courtesy of Mary E. Poindexter Hennen.)

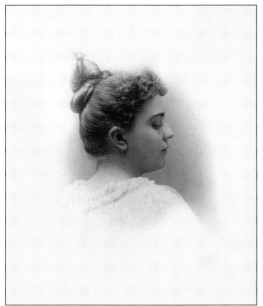

Garnet Page and Will Kahler are the happy couple seen here for whom the church sanctuary, pictured on the previous page, had been decorated. One day a few years after their wedding, while Kahler was waiting for a streetcar to Huntington, he hopped over a fence to catch a white rabbit. The rabbit turned out to be a skunk, and Kahler canceled his trip into the big city. (Both courtesy of Mary E. Poindexter Hennen.)

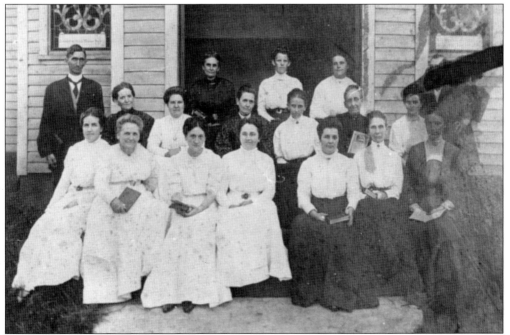

The Southern Methodist Church's Ladies Aid Society poses with Sunday school superintendent Frank Thornburg (top left) and Pastor S.H. Auvil (top right) in 1908. Minutes for the ladies' meeting of February 14, 1906, say, "there was plenty of work on hand but spent the afternoon in talking." (Courtesy of Mary E. Poindexter Hennen.)

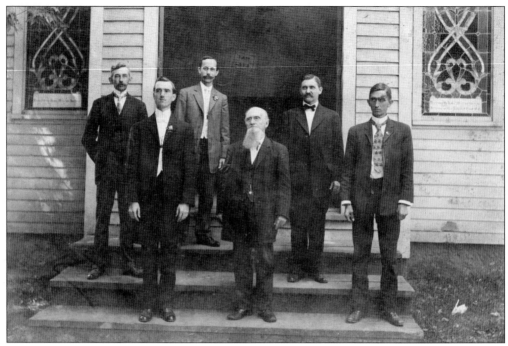

Southern Methodists pose in 1906. They include, from left to right, (first row) Pastor Robert Yoak, presiding elder ? Wade, and Frank Thornburg; (second row) H.O. Thornburg, John Beale, and John C. Hennen. Please note that the Hennen family member is the father of John Carlton Hennen Sr. and grandfather to John Carlton Hennen Jr. (Courtesy of Mary Margaret Hennen Withers.)

SCENE ON MAIN STREET, EAST HUNTINGTON, W. VA.
FORMERLY GUYANDOTTE.

This bucolic postcard scene, which was published sometime between 1910 and 1915, shows the 200 block of Main Street paved with bricks and pleasantly shaded by plenty of trees. The Southern Methodist Church's steeple in the next block rises above the foliage, crowned with a weather vane. (Courtesy of Mary Margaret Hennen Withers.)

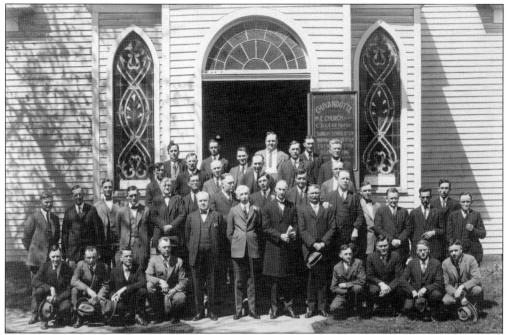

The men's Sunday school class of the Guyandotte Methodist Episcopal Church–South poses with Pastor Charles Lear, who is seen at front center with a boutonniere in his lapel. Lear served the church twice—from 1915 to 1917 and 1921 to 1924. (Courtesy of Nellie M. Moore.)

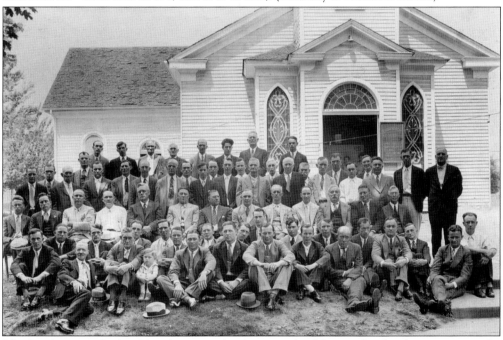

The Southern Methodist Church's men's class kept up a healthy membership for years. Here, the men pose with Pastor Clark C. Perkins in 1933 or 1935. Perkins, who served the church from 1932 to 1936, is the man with white hair, glasses, and a dark jacket sitting fifth from the left in the second row. (Courtesy of Carl Withers.)

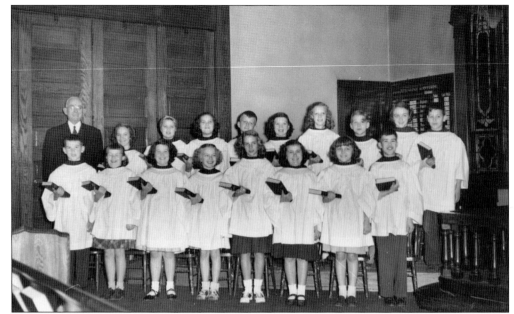

In 1950, Guyandotte Methodist Church's north and south congregations reunited in the 1870 sanctuary at 305 Main Street. Here, a children's choir poses with Pastor W.A. Debar, who served the church from 1945 to 1953. The folding wooden doors lead to the congregation's lecture room. (Courtesy of Mary Margaret Hennen Withers.)

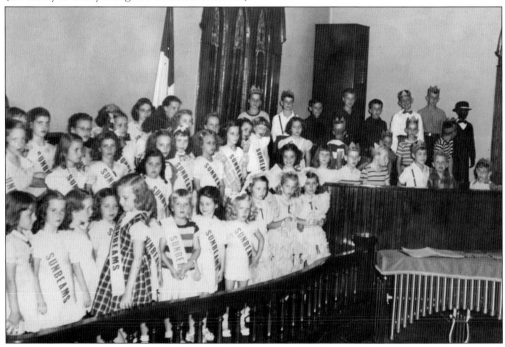

A little time later, the children's choir had grown and came to be known as the Sunbeams, who are seen here adorned with decorative sashes. The youngsters, who are performing during a revival, fill up the choir loft at right and the entire area behind the altar. (Courtesy of Mary Margaret Hennen Withers.)

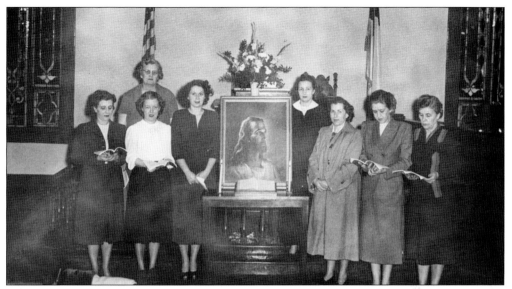

The Guyandotte Methodist Church's Fidelis Sunday school class poses around the pulpit and altar in the early 1950s. Elizabeth Garrette stands behind Mike Burks, Bea Lawwill (left), and an unidentified woman at left, and on the right side, another unidentified woman stands behind, from left to right, Juanita Messinger, Martha Withers, and Margaret Bunch. (Courtesy of Mary Margaret Hennen Withers.)

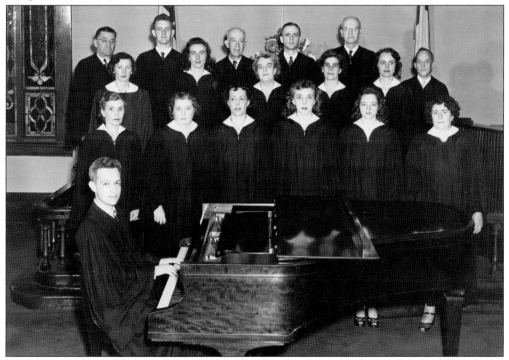

The Guyandotte Methodist Church's choir poses with director Leland W. Thornburg sometime in the early 1950s. The congregation's grand piano has been moved over to a position in front of the altar for the occasion. It is believed the choir was posing for a publicity photograph to advertise a coming revival. (Courtesy of Mary Margaret Hennen Withers.)

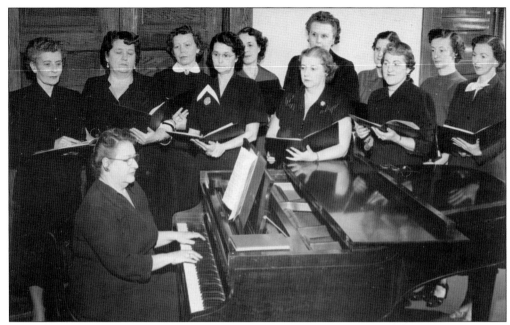

The piano has been returned to its customary place in the Methodist church for a rehearsal of the Guyandotte Woman's Club's "Mother Singers" directed by Helen Stephenson. The singers include, from left to right, Mike Burks, unidentified, Florence Edwards, Lora Rogers, Virginia Kelly, Mary Margaret Hennen Withers, Lois Alexander, Pauline Hughes, Elmira Beard, Shelia Rowsey, and Mildred "Midge" Rowsey. (Courtesy of Mary Margaret Hennen Withers.)

Mary E. Poindexter Hennen poses with Gerald Michael "Mickey" Debar, grandson of the Reverend W.A. Debar, pastor of Guyandotte Methodist Church from 1945 to 1953. Mickey lived with his grandparents while they served at Guyandotte. The family was among the most beloved to occupy the Methodist parsonage. (Courtesy of Mary E. Poindexter Hennen.)

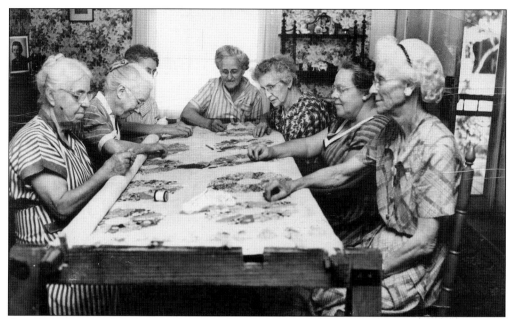

Once Mary E. Poindexter Hennen retired from teaching her Sunday school class at Guyandotte Methodist Church, she and several of the classmates formed a group to meet in her home and produce quilts to sell for the church treasury's benefit. Here, on Thursday, October 1, 1953, the quilters include, from left to right, Hennen, Leona Lawwill, Stella Everett, Mollie Whittle, Ann Wilson, Ida Kirby, and Anna Woods. (Courtesy of John Carlton Hennen Jr.)

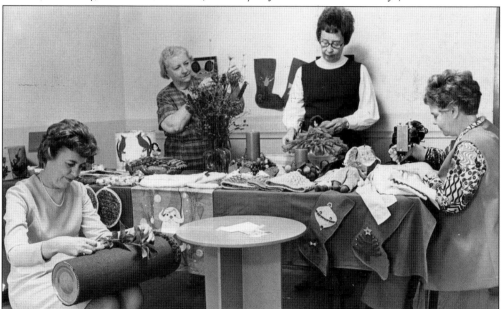

Four women—from left to right, Luella Murphy, Mary Margaret Hennen Withers, Alice Cartte and Jo Ann McComas—prepare items for a Christmas bazaar in the Guyandotte United Methodist Church's social hall around 1970. Note that "United" is part of the church's name now, since most Methodist churches had merged with most congregations of the Evangelical United Brethren Church. (Courtesy of the *Herald-Dispatch*.)

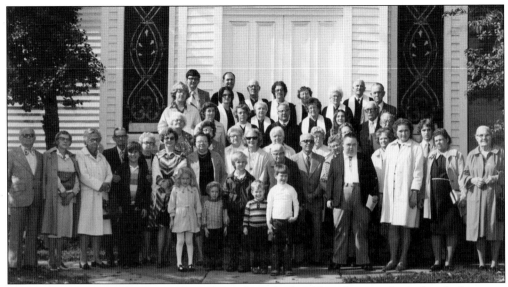

The congregation of the Guyandotte United Methodist Church poses for a church directory photograph with its pastor, the Reverend Charles Potts, in 1977. Potts is in the center of the group on the steps, wearing glasses and a black choir robe minus its stole. (Courtesy of Mary Margaret Hennen Withers.)

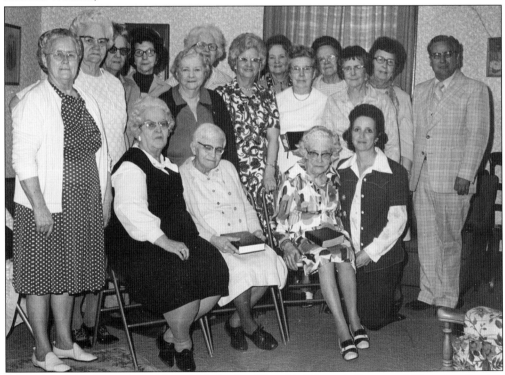

Members of the Guyandotte United Methodist Church's Women's Society of Christian Service pose with their pastor, Rev. Charles Potts, during a meeting in the parlor of Elizabeth Garrette's home at 302 Main Street around 1978. Garrette is the lady with white hair partially hidden near the center of the back row. (Courtesy of Mary Ann Saunders.)

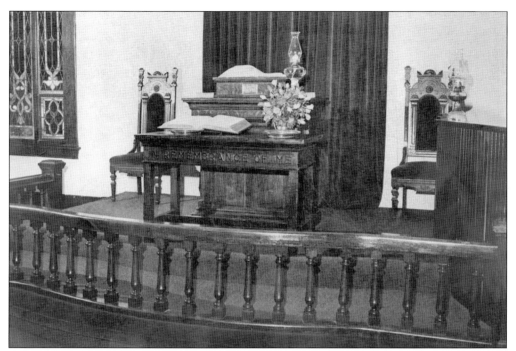

A kerosene lamp has been placed on the pulpit at the Guyandotte United Methodist Church in time for a homecoming on Sunday, October 25, 1970. The special day's morning worship service will be followed by a covered-dish dinner, a love feast filled with singing and reminiscing, and an evening lamplight service. (Courtesy of the *Herald-Dispatch*.)

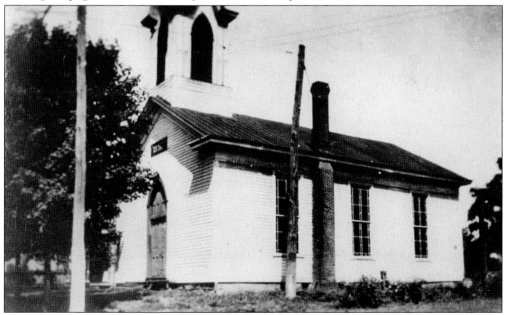

In 1858, soon after those Methodists who sided with the North before the Civil War separated from their Southern sympathizers, they built this church in the 200 block of Bridge Street. It was one of the buildings not burned during the conflict because Union troops used it as a local headquarters. (Courtesy of Mrs. Jack Hines.)

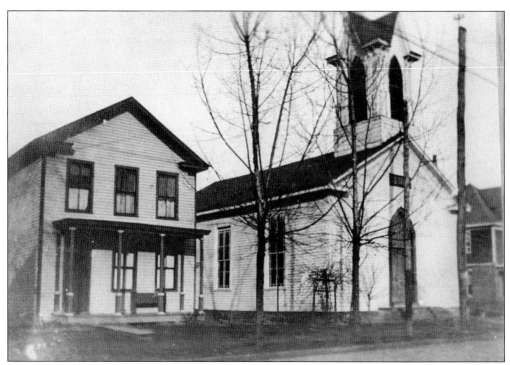

Here is another view of the Guyandotte Methodist Episcopal Church–North taken from the West in about 1910, which also shows its parsonage. The church building also was known as the Bridge Street Methodist Church. In later years, the pastors' home was moved to the back of the lot to make room for a brick barbershop. (Courtesy of Mrs. Jack Hines.)

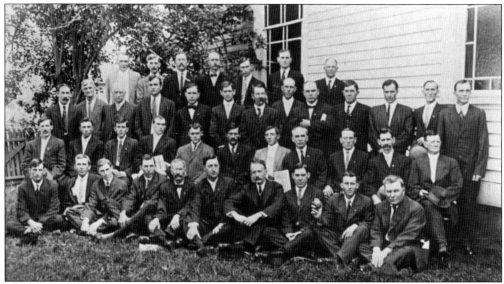

Members of the fairly large men's class of the Guyandotte Methodist Episcopal Church–North pose beside their sanctuary in 1912. Their pastor, the Reverend P.Y. DeBolt, is sixth from the left in the first row. Civil War rivalries have largely been forgotten at the time this photograph was taken, and reunification of the north and south branches of the congregation is not far in the future. (Courtesy of Creed Neff.)

Weary of having their sanctuary damaged by floods, especially the 1913 inundation, members of the Bridge Street Methodist Church's congregation jacked up their sanctuary and built a brick basement under it. The presence of construction materials in this 1915 photograph indicates that their work is nearly finished. Pastor H.R. Mills is the man with the white coat and straw hat standing under the small shade tree. (Courtesy of the *Herald-Dispatch*.)

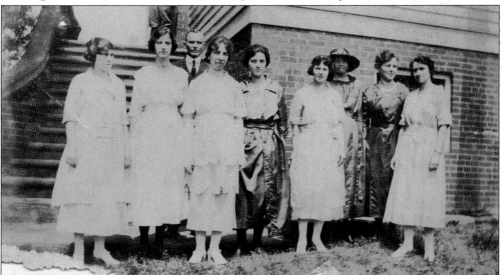

The Bridge Street Church's basement has been dedicated, and several ladies pose with Pastor Mills beside it. The two women to the far right are sisters Charlotte Dugan Moore (left) and Pearl Dugan Wheatley. Bishop Earl Cranston, who dedicated the brick structure, was the officer who used the frame sanctuary as a Union headquarters during the Civil War. (Courtesy of Mary Margaret Hennen Withers.)

Lavenia Dugan's Sunday school class, one of Huntington's largest, poses in front of the newly enlarged Bridge Street church with 83 scholars in 1915. Dugan is believed to be the woman wearing the large hat and standing on the steps at left. (Courtesy of Charlotte Dugan Moore.)

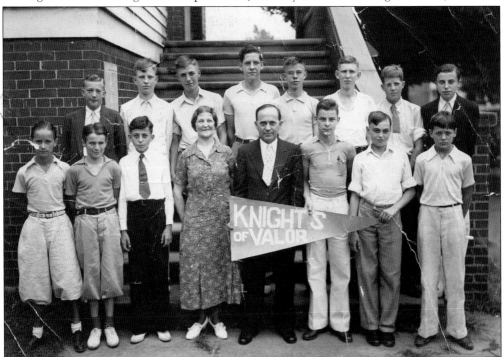

Members of Anna West "Miss Anna" Worden's Knights of Valor Sunday school class pose beside the Bridge Street church in 1949—just before the North and South congregations reunited. Miss Anna, beloved by many because she took neighborhood children with her as she walked to church and wrote encouraging letters to them through the week, is fourth from left in the first row. (Courtesy of the *Herald-Dispatch*.)

The First Guyandotte Baptist Church at 219 Richmond Street was constructed around 1867 after the original brick building, which sat on the same foundation, was burned by Union soldiers on November 11, 1861. On the eve of Guyandotte's sesquicentennial celebration on July 4, 1960, the congregation started an annual tradition of meeting on Sunday night in period costumes and singing from hymnbooks illuminated by kerosene lamps. (Courtesy of Bob Withers.)

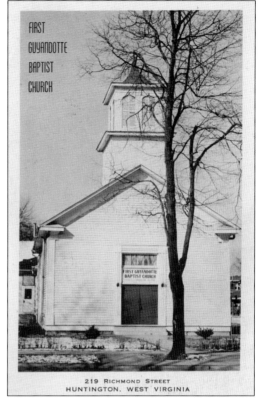

219 RICHMOND STREET
HUNTINGTON. WEST VIRGINIA

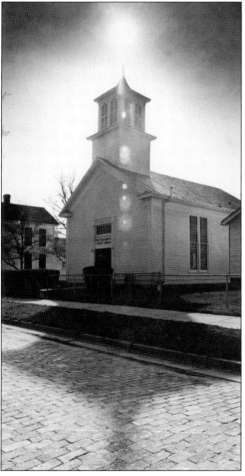

A newspaper photographer, noting the position of the sun, could not resist capturing this more recent image of the First Baptist Church of Guyandotte. The building still welcomes worshipers and conducts an occasional nostalgic lamplight service today. The parsonage (left) was torn down several years ago. (Courtesy of the *Herald-Dispatch*.)

87

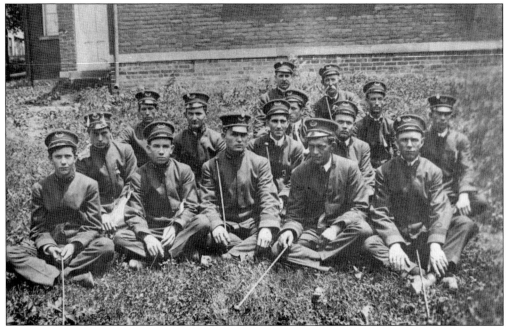

The Riverside Band of Huntington poses beside St. Peter's Catholic Church on South High Street in this undated photograph. Perhaps the musicians were getting ready to perform a concert at the church or provide music for a memorial service in the adjoining cemetery. The building is gone, but St. Joseph's Church in downtown Huntington keeps up the cemetery. (Courtesy of the *Herald-Dispatch*.)

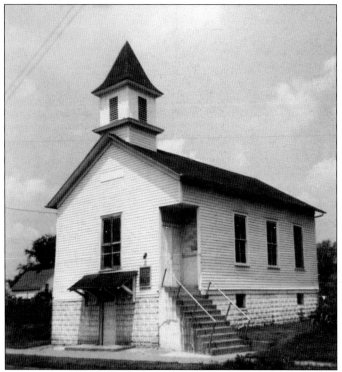

The Second Baptist Church of Guyandotte, located on the northwest corner of Fifth Avenue and Short Street, was where the town's African American community attended services. The building was torn down sometime in the mid-1970s to make room for a Huntington Housing Authority high-rise apartment building. (Courtesy of Mary E. Poindexter Hennen.)

*Six*

# SCHOOLS AND SCHOLARS

The original Guyandotte Elementary School, built in the 600 block of Third Street in 1878, was nearly out in the countryside at the time. Ten years later, the Ohio River Railroad—later taken over by the Baltimore & Ohio—came through behind the building, its trains doubtlessly interrupting teachers with their melodious steam whistles. (Courtesy of Merlyn Diddle.)

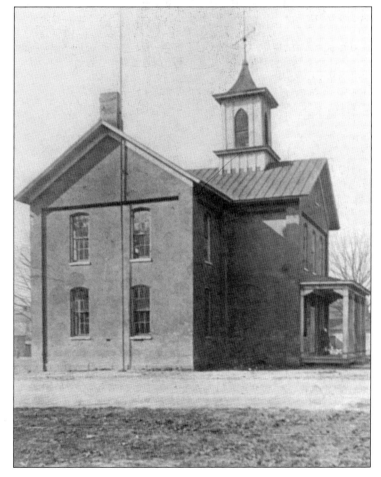

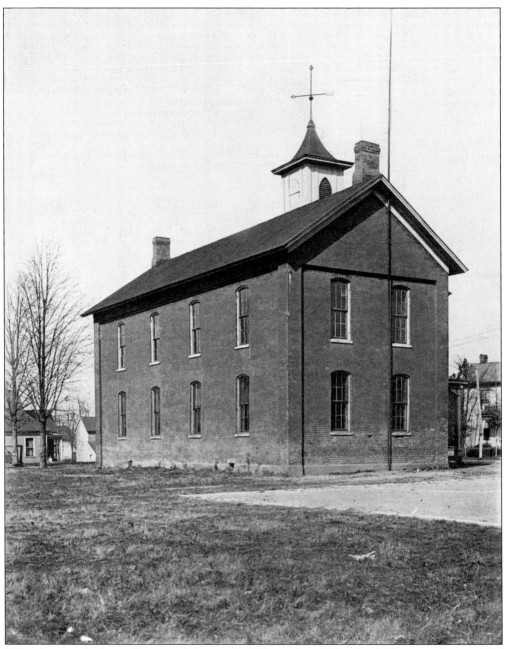

This photograph shows the rear of the original Guyandotte School, which was constructed of brick and contained four rooms. Lifelong school employee Helen Diddle, who died in November 2013, two weeks after her 105th birthday, wrote on the back of the picture, "This is where I got my start." (Courtesy of Helen Diddle.)

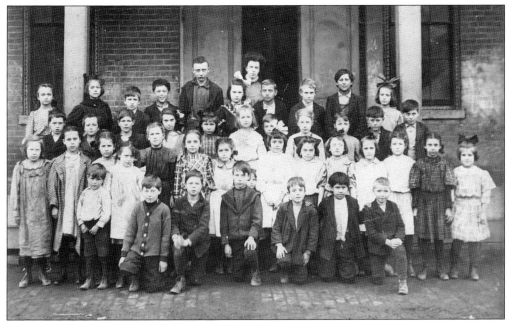

Roxie Lindsay's third-grade class poses at the original Guyandotte School around 1915. The lack of smiles on most of those little faces indicates that they may have been wishing they could be enjoying recess on the playground rather than holding still for the slow cameras of that era. (Courtesy of Mary Margaret Hennen Withers.)

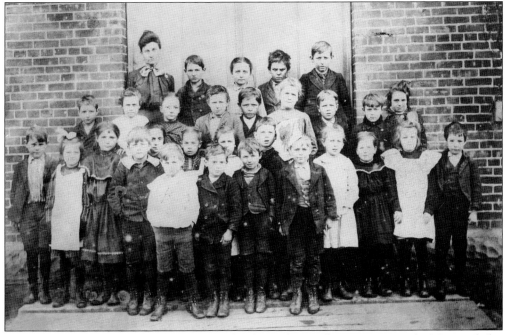

Overcrowding at the original Guyandotte School forced some classes to meet in the Masonic lodge hall at 222 Richmond Street. Here is Elma Hennen's class in 1907. Stanlie Burks, the photograph owner's future husband, is the first child at left in the first row. Her sister Virginia Salmon is third from left in the second row. (Courtesy of Mike Burks.)

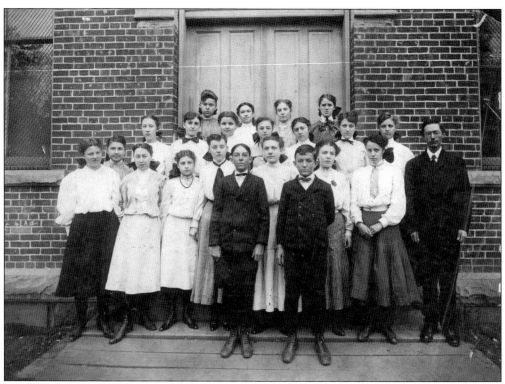

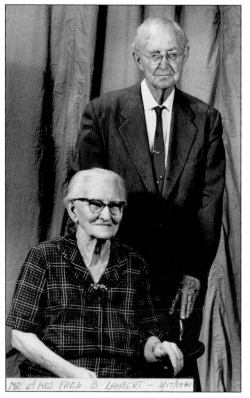

MR. & MRS. FRED B. LAMBERT - 3/17/1961

Another class of Guyandotte Elementary School meets at the Masonic Lodge on Richmond Street in this undated photograph. The grade in view here is not known to the author, but the gentleman standing at right is teacher and principal Fred Lambert. (Courtesy of Special Collections, Marshall University.)

This studio photograph Fred Lambert and his wife is dated March 17, 1961, indicating that Fred, at one time a teacher and principal at Guyandotte Elementary School, enjoyed a long career as an educator in the Cabell County school system. (Courtesy of Special Collections, Marshall University.)

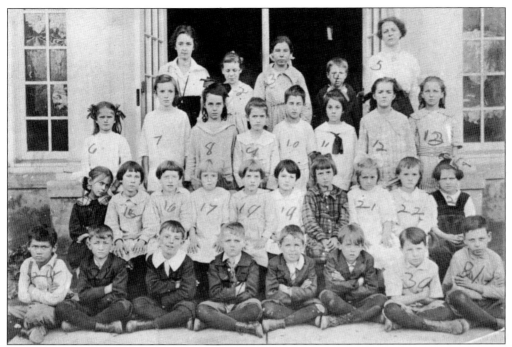

In this May 1918 photograph, the new Guyandotte School is in use. Miss Kent (top left) and Miss Goodman (top right) teach 29 third-graders between the two of them. Young John Carlton Hennen Sr., a future bank vice president, is fourth from the left on the first row. (Courtesy of Mary E. Hennen.)

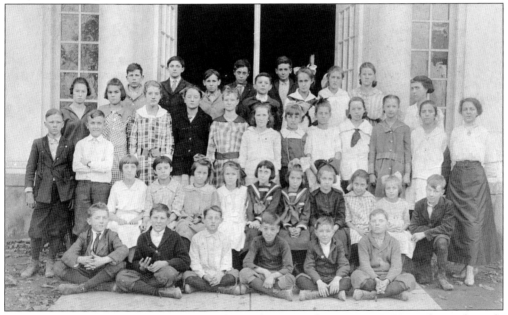

Every class in the new Guyandotte School must have posed in May 1918. Here, the sixth-grade classes of Harriet Gardner and Sadie Sanatora take their turn before the lens. Mary Margaret Hennen, the author's mother, is the seventh girl from the left in the second row, wearing a dark dress and hair ribbon. (Courtesy of Mary E. Hennen.)

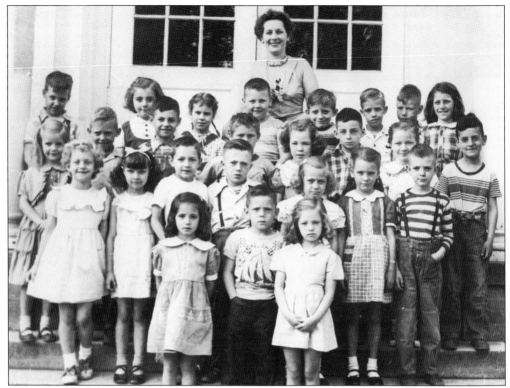

The first-grade class of Almeda Hogsett poses at the west entrance of Guyandotte Elementary School in the spring of 1952. The boy in the top left lowering his face is the author. In future years, his daughters would be the third generation of his family to attend school at Guyandotte. (Courtesy of Mary Margaret Hennen Withers.)

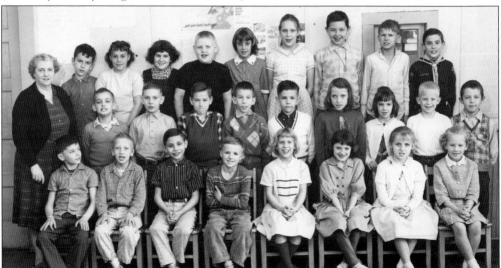

In this late 1960s photograph, Mary Margaret Hennen, the little girl pointed out in an image on the previous page, is now grown up, married to Carl Withers, they have a son of their own (pointed out in the picture above), and is teaching a class of her own at Guyandotte Elementary School. (Courtesy of Mary Margaret Hennen Withers.)

Harry Thomas Moore, who eventually became the author's grandfather-in-law, has climbed up to the top of the new Guyandotte Elementary School while it is being built one reckless day in his younger years. It is unknown who went with him to snap the shutter for this photograph, but maybe it was his brother Guy "Skinny" Moore, who would later work as a janitor at the school. (Courtesy of Bill and Betty Moore.)

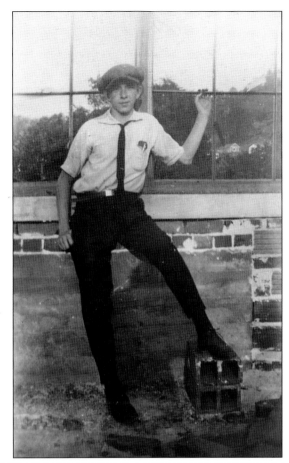

As seen here, the teacher-pupil ratio was a bit skewed at Guyandotte High School's commencement on April 27, 1894—one superintendent, five teachers, and three graduates. These were the good ol' days, spiritually speaking, when school programs began and ended with prayer. (Courtesy of Mary E. Hennen.)

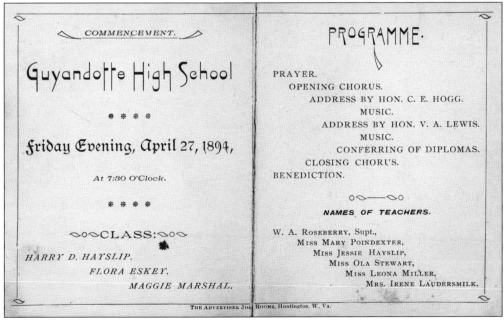

COMMENCEMENT.

# Guyandotte High School

* * * *

friday Evening, April 27, 1894,

At 7:30 O'Clock.

* * * *

CLASS:

HARRY D. HAYSLIP,
FLORA ESKEY,
MAGGIE MARSHAL.

## PROGRAMME.

PRAYER.
OPENING CHORUS.
ADDRESS BY HON. C. E. HOGG.
MUSIC.
ADDRESS BY HON. V. A. LEWIS.
MUSIC.
CONFERRING OF DIPLOMAS.
CLOSING CHORUS.
BENEDICTION.

**NAMES OF TEACHERS.**

W. A. ROSEBERRY, Supt.,
MISS MARY POINDEXTER,
MISS JESSIE HAYSLIP,
MISS OLA STEWART,
MISS LEONA MILLER,
MRS. IRENE LAUDERSMILK.

THE ADVERTISER JOB ROOMS, Huntington. W. Va.

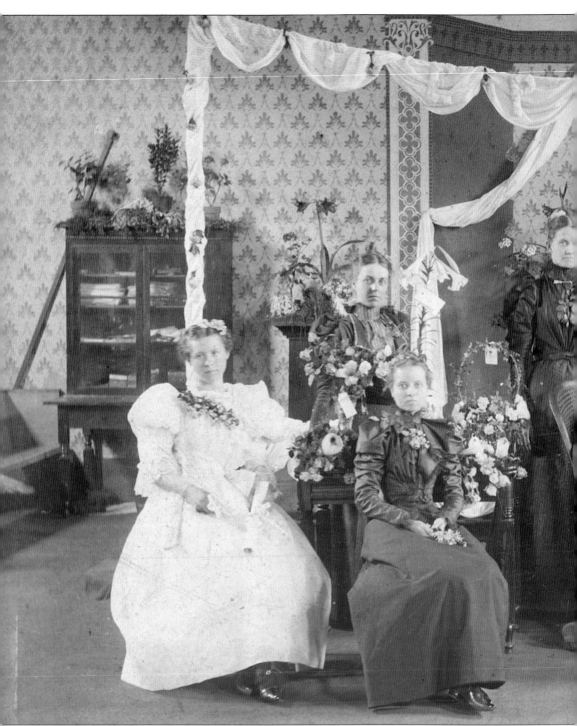

The teacher-pupil ratio has not changed much for Guyandotte High School's commencement at the Bridge Street Methodist Church on May 5, 1897. As a matter of fact, it is exactly the same—one principal, five teachers, and three graduates. Posing from left to right are (seated) graduate Josie Roberts; teacher Anna Baker; Professor Burdette, the principal; graduate Matthias

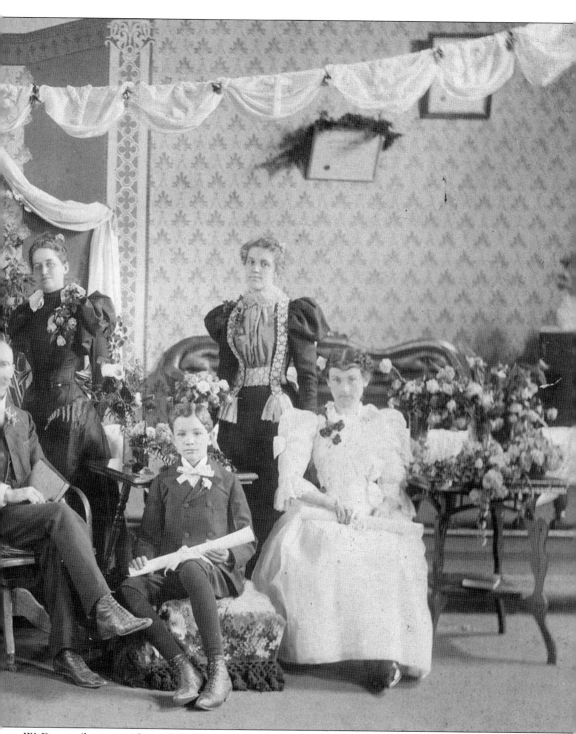

W. Dugan (later president of the Emmons-Hawkins Hardware Co. in Huntington); and graduate Lizzie Tauber; (standing) teacher Mary E. Poindexter, teacher Irene Loudermilk, teacher Rose Fetty, and teacher Lena Shorter. Flowers are in abundance, and the students appear to be holding diplomas. (Courtesy of Mary E. Poindexter Hennen.)

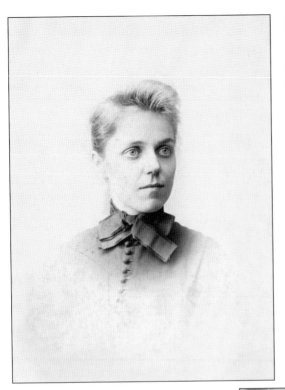

Here is a close-up of Mary E. Poindexter taken during her school-teaching days. At one time, she rode C&O trains from Guyandotte to the Blue Sulphur Hotel, nine miles eastward, and walked another two miles to a school at Ona. She married John C. Hennen in 1905. (Courtesy of Mary Margaret Hennen Withers.)

This is Rose Fetty, another Guyandotte schoolteacher, who was a close friend of colleague Mary E. Poindexter. She seems to be striking a scholarly pose. She and several of her descendants were active for years in the Guyandotte Methodist Episcopal Church–South, as was her friend Mary. (Courtesy of Mary Margaret Hennen Withers.)

## Seven

# WHEN THE "CREEK" DOES RISE

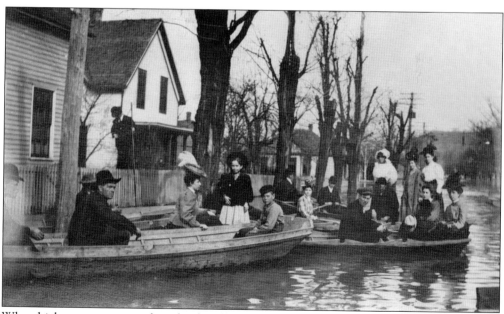

When high water covers roads and railroad tracks, people must resort to boats for travel. Here are three vessels in the 200 block of Bridge Street carrying Guyandotters here and there on March 18, 1907. The only person identified is T.C. Rogers, who is using a balancing pole as he walks along the top of a fence. (Courtesy of Mrs. Jack Hines.)

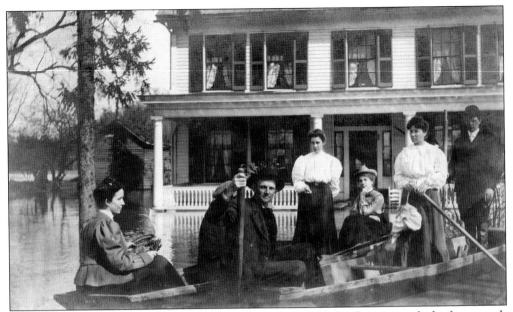

The Clark family appears to be evacuating as the March 1907 floodwaters reach the front porch of their fine home at 524 Main Street, which still stands today. The photographer appears to be positioned about where a flood wall was constructed in the 1940s. (Courtesy of Mrs. Jack Hines.)

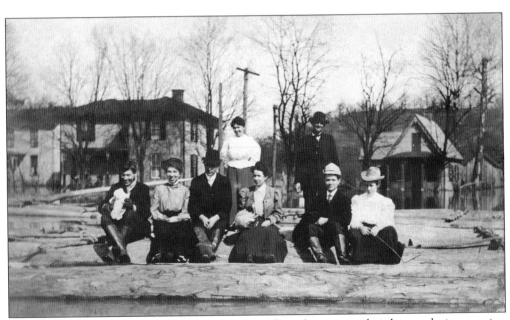

Several Guyandotters are seated on logs that have floated over near their homes during a spring flood on the Guyandotte River along upper Main Street. The modest home at right is the only one in the photograph that still stands today; back then, it was owned by Emma McMahon. (Courtesy of Mary Margaret Hennen Withers.)

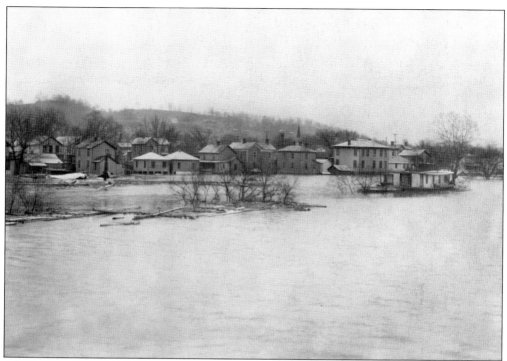

Effects of the 1913 flood upon Guyandotte are visible in this image taken from a boat on the swollen Ohio River. The steeple of the Guyandotte Methodist Episcopal Church–South, also known during those years as the Main Street Methodist Church, is in the distance. (Courtesy of Special Collections, Marshall University.)

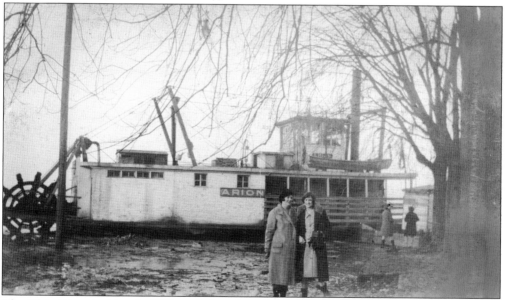

The Ohio River is rising in 1913, and the pilot of the ferry *Arion* from Proctorville, Ohio, has been forced to find a different place to land on the Guyandotte side of the swollen stream. The two people at bottom right appear to be ready to climb into a rowboat of some kind to reach the ferry. (Courtesy of Mary Margaret Hennen Withers.)

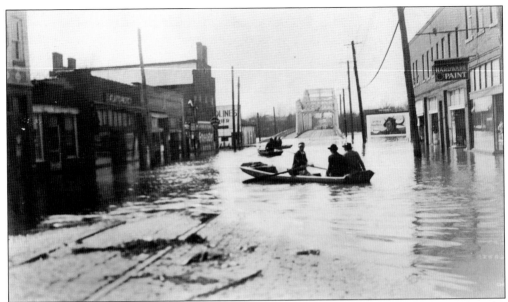

It is January 1937, and a terrible flood is coming. Several businesses already are blocked in the 100 block of Bridge Street. Neither the A&P and Kroger stores, Henry Metz's bakery, George Nebert's secondhand furniture store, Benjamin Brasley's dry goods emporium, Jones Hardware, Fred Rust's barbershop, the Hamburger Inn No. 6, or the Guyan Cafe will do much business on this day. (Courtesy of Mary Margaret Hennen Withers.)

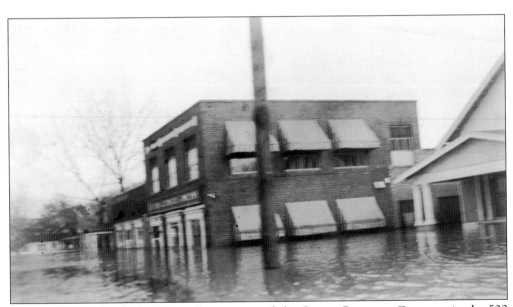

The Ohio River flood of 1937 rapidly rises around the Guyan Creamery Company in the 500 block of Bridge Street. No one will be walking into the retail store to buy an ice cream cone in this torrent. (Courtesy of Mary Margaret Hennen Withers.)

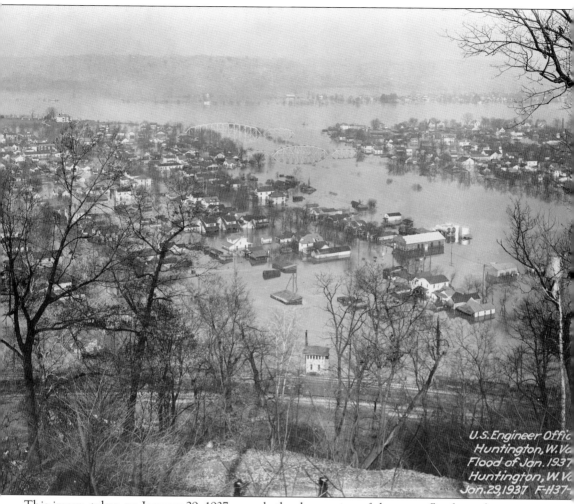

This image, taken on January 29, 1937, reveals the devastation of the worst flood to submerge the tristate area to date. The Ohio River runs horizontally at the top. Guyandotte is at top right, and the bridges connecting it to the rest of Huntington are impassable. The C&O Railway's tracks and DK Cabin, a telegraph office, are in the foreground. The Ohio River flood of late January and early February 1937 left 385 people dead, a million people homeless, and property losses upward of $500 million. Federal and state recovery resources were strained to the limit because the destruction occurred so shortly after the Great Depression and the Dust Bowl. This cloud did have a silver lining—civic and industrial organizations lobbied Congress to formulate a national flood control plan that eventually, by the early 1940s, led to the construction of more than 70 reservoirs to contain tributary waters that would have flowed uncontrollably into the Ohio, which reduced the heights of floods along that major river. (Courtesy of the US Army Corps of Engineers.)

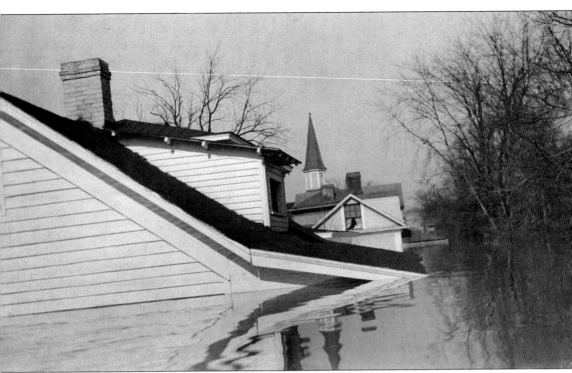

The 1937 flood also affects private residents and a church in the 300 block of Main Street. The home at 317 is in the foreground. The dormers of the author's current home at 313 are visible behind it, as is the steeple of the Guyandotte Methodist Episcopal Church–South at 305. The floodwaters completely filled the first floor of old 313, but the house was so well built that the only problem for owner Mary E. Hennen when she returned to it was a few swollen doors of built-in cabinets that never closed snugly again. She had been through so many floods that she was determined to move out to the Beverly Hills section of Huntington and rent out the house. After a year, she missed Guyandotte so much that she kicked out the tenants and moved back home. In this picture, it looks like the sun is out, so perhaps things dried out quickly. (Courtesy of Mary Margaret Hennen Withers.)

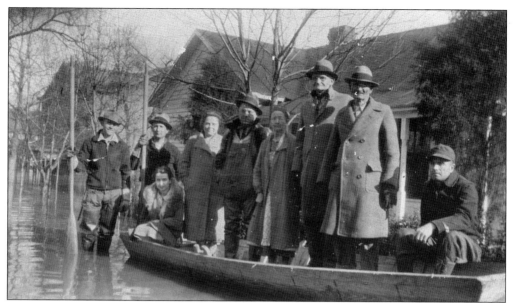

Seven people—from left to right, Helen Diddle (seated), Ida Kirby, Fred Wells, Augusta and Allen Lee Diddle (Helen's parents), an unidentified man, and Elza Elsworth Moore—are in a boat in front of 306 Depot Street, preparing to evacuate the neighborhood. Standing behind the vessel are Bill Kirby (Ida's husband), left, and Merlyn Diddle (Helen's brother). The son of the pictured Merlyn Diddle provided the photograph. (Courtesy of Merlyn Allen Diddle.)

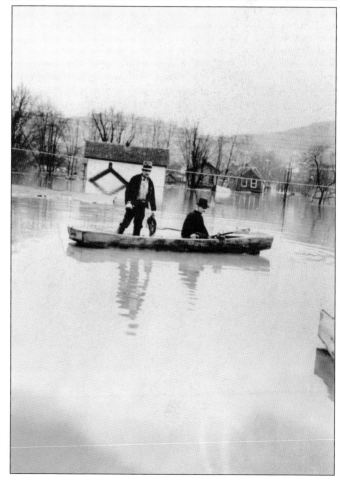

Harry Wilcox (left) and his son, the Reverend Clayton Wilcox, sail through the waters of the 1937 flood behind 222 Buffington Street in a johnboat. Harry is holding a large fish that he can probably brag about catching on his own property, which is located more than three blocks from the Ohio River. (Courtesy of Damon Wilcox.)

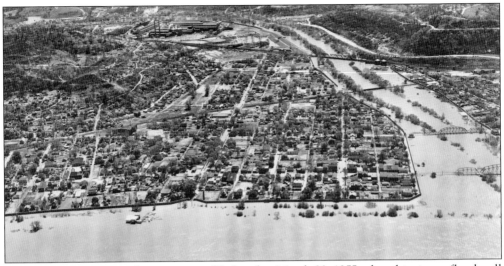

Flooding came to Guyandotte again on Wednesday, March 23, 1955—but this time a flood wall protected its homes, churches, schools, and businesses. This aerial photograph looks south, and from bottom to top, shows the Third Avenue, Fifth Avenue, and the B&O Railroad and C&O Railway bridges. (Courtesy of the *Herald-Dispatch*.)

An employee of the International Nickel Co. drives off the Roby Road bridge and through high water in the 1960s to get to the plant's parking lot inside the flood wall. The photograph was made from a wooden walkway the plant built for men to walk across the swollen Guyandotte River from US 60, which was on higher ground. (Courtesy of Damon Wilcox.)

*Eight*

# GETTING AROUND

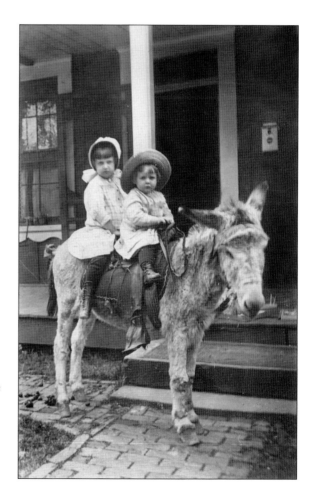

Mary Margaret Hennen (left) and her brother John Carlton Hennen Sr. pose on a donkey in front of their home at 313 Main Street in about 1911. If the children are scared, they do not show any evidence of it. The donkey does not seem to mind either. (Courtesy of Mary Margaret Hennen Withers.)

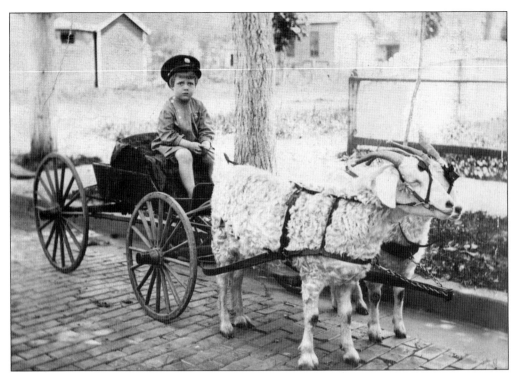

Little John Carlton Hennen Sr., or "Buddy," as he was called, is a little older now as he poses on a carriage hitched to a couple of billy goats near his home in about 1914. The cap may be one usually worn by his uncle, Capt. John Poindexter of the Guyandotte Fire Department. The lad eventually grew up to be a bank vice president. (Courtesy of Mary Margaret Hennen Withers.)

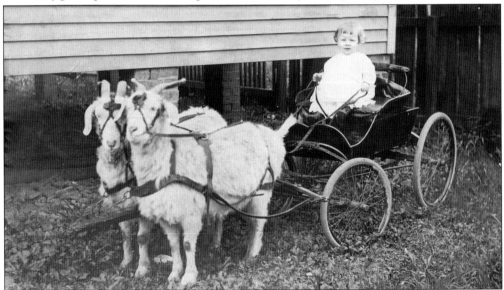

Animals seem to have been the preferred method of travel for youngsters in Guyandotte's early days. Charles Moore, who appears to be about three years old here, seems to be ready to take a joyride around the block behind a couple of (hopefully tame) billy goats. (Courtesy of Mary Ann Saunders.)

Geraldine Withers (left) and her sister Emogene pose with a donkey in front of their home at 3606 Third Avenue in 1935 or 1936. A traveling photographer hauled the animal around the neighborhood for years, asking children to pose with it—with the resulting picture likely causing parents to part with some small change. (Courtesy of Geraldine Withers Perry.)

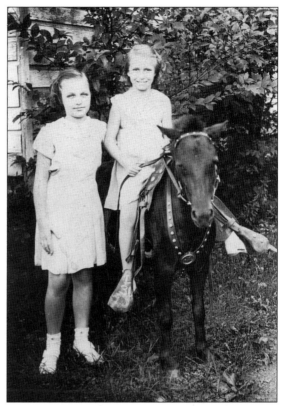

The first bridge at Guyandotte was this suspension span, built in 1856 and seen below in the 1870s. Houseboats are tied up on the west bank of the Guyandotte River, and Ohio Valley Electric Railway's streetcar barn and the home of Delos Emmons, Collis P. Huntington's brother-in-law, can be seen in the distance. Emmons bought the home from Jonathan Buffington. (Courtesy of Merlyn Diddle.)

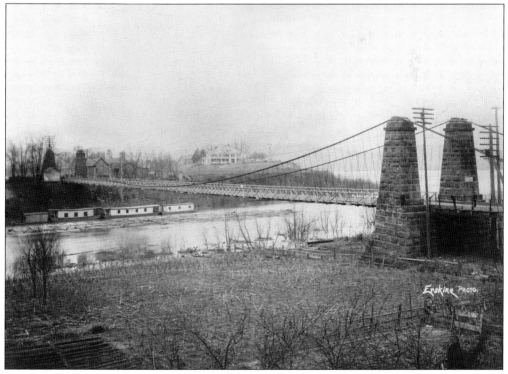

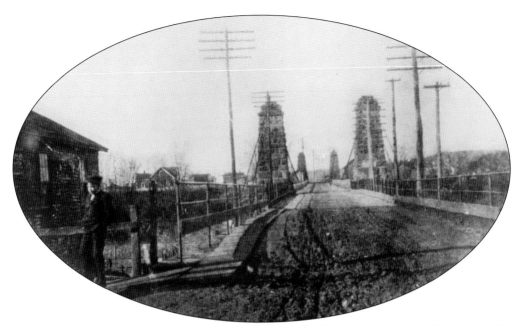

Young Irvin Dugan loafs near the east end of the Guyandotte suspension bridge around the late 18th century. He grew up to work as the nationally celebrated staff artist for the afternoon *Huntington Advertiser* and the Sunday *Herald-Advertiser* between 1927 and 1957. (Courtesy of Special Collections, Marshall University.)

Workers who replaced Guyandotte's suspension bridge with this modern span pose with townsfolk at its dedication on October 3, 1907. The daredevil worker at top right fell to the ground shortly after this image was captured. He landed on his feet unhurt but died later in a similar incident. (Courtesy of Bob Withers.)

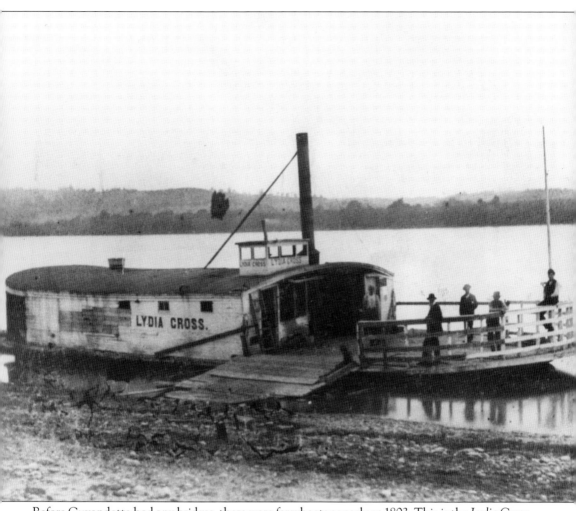

Before Guyandotte had any bridges, there were ferryboats as early as 1803. This is the *Lydia Cross*, which brothers George and Billy Bay placed in service on the Ohio River between Guyandotte and Proctorville, Ohio, in 1840. The Smith brothers took over its operation later. (Courtesy of G.W. "Jerry" Sutphin.)

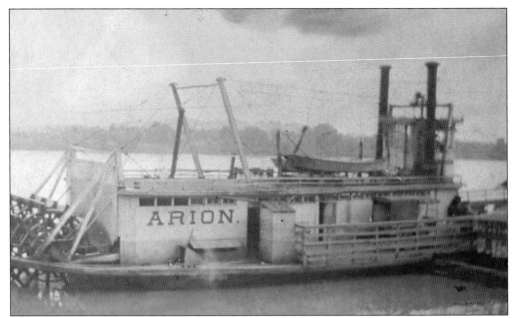

Passengers rode between Guyandotte and Proctorville aboard the ferry *Arion* after it was built in 1891. It remained in service until 1929, when a fire destroyed it. As long as a passenger did not get off, he or she could ride back and forth all day and into the evening for only a nickel. (Courtesy of Special Collections, Marshall University.)

Taken from a distance, this photograph shows the ferry *Arion* making one of her several daily trips from Proctorville to Guyandotte. Multiple voyages across the Ohio River could be a source of great enjoyment on a hot afternoon in the days before radio, television, cell phones, iPads, and other modern technological marvels. (Courtesy of Mary Margaret Hennen Withers.)

Six Guyandotte men—from left to right, Glen Foster, Arleigh Worden, Marion Dusenberry, Myron Neale, Charles Howard, and Irvin Dugan—pose with a brand new streetcar at "Murphy's Corner" on Bridge and Main Streets in 1913. St. Louis Car Co. built the car no. 101 and its seven siblings (Ohio Valley Electric Railway Co. nos. 102–108) in August of that year. (Courtesy of the *Herald-Dispatch*.)

Ohio Valley Electric Railway Co.'s vintage 1913 streetcars rocked and rattled over the Third Avenue line between downtown Huntington and Guyandotte for 14 years before the company sold them to the Altoona and Logan Valley Traction Co. in Pennsylvania. In these 1918 views, conductor W.H. Thompson, pictured left, equipped with a ticket punch and coin changer, and motorman Bill Gwinn, below, pose for each other at Buffington Street before returning downtown on car no. 107. Gwinn, who later worked for a streetcar line in Bridgeport, Ohio, always carried his camera with him and produced scores of local streetcar photographs. (Both courtesy of William Jennings Bryan Gwinn.)

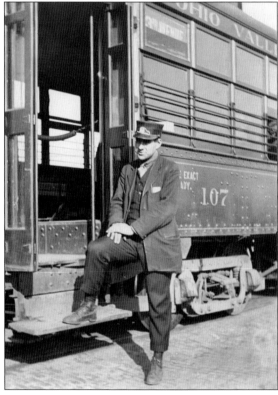

In 1937, the Ohio Valley Electric Railway Co. completed a 12-year transition to the Ohio Valley Bus Co. Here, two buses look like they are having trouble passing each other at the south end of the Roby Road bridge along US 60, the entrance to Guyandotte from the South, in about 1956. (Courtesy of Leonard Samworth Jr.)

This February 14, 1974, image was taken on Riverside Drive at the north end of the Roby Road bridge in front of the employees' parking lot of the International Nickel Co. The expansive factory, which was established in 1922 and is called Special Metals today, always has been called "the nickel plant" by Guyandotters. It looks like no one needs to board bus no. 5017. (Courtesy of the *Herald-Dispatch*.)

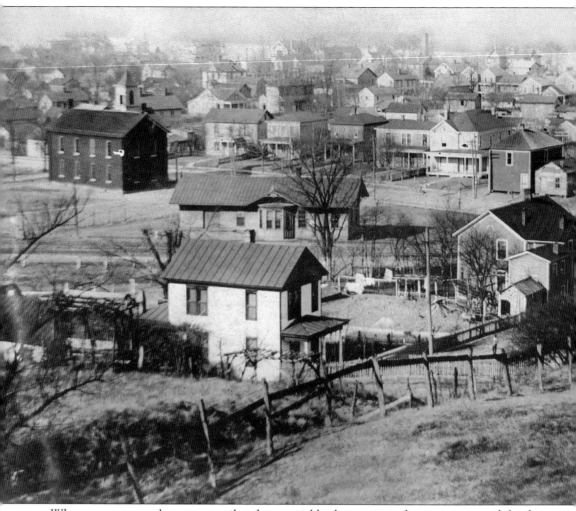

When a person must leave town, railroads are a viable alternative to the private automobile when a town is too small for an airport. In the center of this photograph is Guyandotte's Baltimore & Ohio Railroad station, where four passenger trains stopped in 1900. The brick building to the left of the depot is the original Guyandotte Elementary School. (Courtesy of Helen Diddle.)

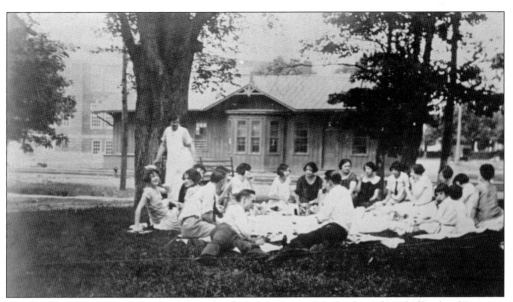

The B&O station serves as a backdrop for the Main Street Methodist Church's Buds of Promise Sunday school class in 1924. Class members enjoy baskets full of food during a picnic on the front lawn of their teacher, Flora Wells (standing left). The second Guyandotte School building is in the left of the background. (Courtesy of Mary Margaret Hennen Withers.)

**Chesapeake & Ohio R. W.**

ONE WAY OF SPECIAL ROUND TRIP TICKET

ONE SEAT.

From Ashland

To GUYANDOTTE

Good until July 5/83

Sold only on Special Order from General Ticket Office.

S.R.T.

20709  N. W. Fuller
Gen. Pass. and Ticket Agent.

Perry Hennen purchased this Chesapeake & Ohio Railway ticket—the second half of a 38-mile round-trip between Guyandotte and Ashland, Kentucky—at C&O's Guyandotte station. The ticket was valid until July 5, 1883. Hennen was in the lumber business for many years. (Courtesy of Mary Margaret Hennen Withers.)

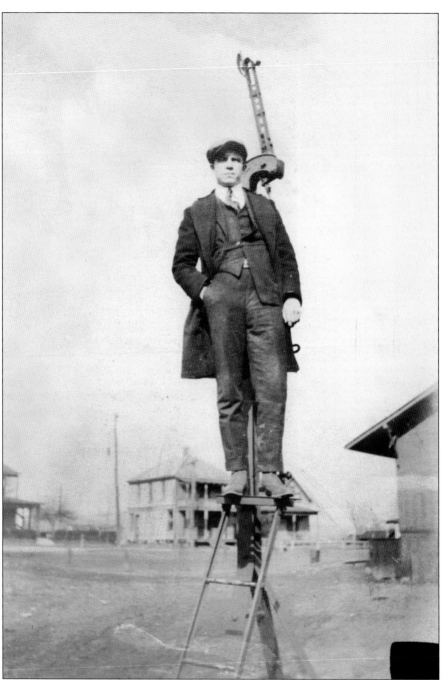

The mail crane at B&O's Guyandotte station provided a handy stand upon which to compose a photograph. Shown is Kenneth Diddle. Mail cranes were devices that allowed local postmasters to hang up sacks of mail so railway post office (RPO) clerks traveling on passenger trains could use their RPO cars' catcher arms to snag the bags without stopping their trains. It was a sight to behold—at the same instant the clerk picked up the outgoing mail, he would kick a bag of incoming mail out of the car for the waiting postmaster to take back to his office. (Both courtesy of Merlyn Diddle.)

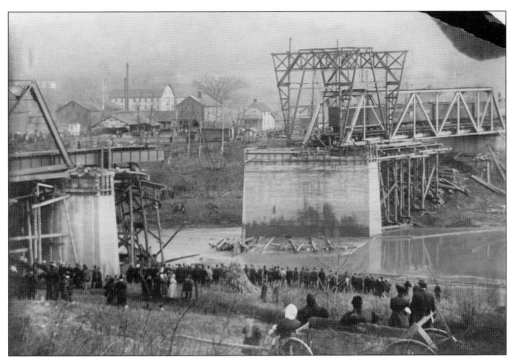

Guyandotte was shaken by the noise of the collapse of the C&O bridge on New Year's Day 1913. Workmen had been double tracking and strengthening the bridge because log rafts had weakened it. Engineer C.B. "Shorty" Webber was warned as crews unloaded a carload of lumber, but he did not listen, and this is the result. Webber and seven bridge workers died. (Courtesy of Mary Ann Saunders.)

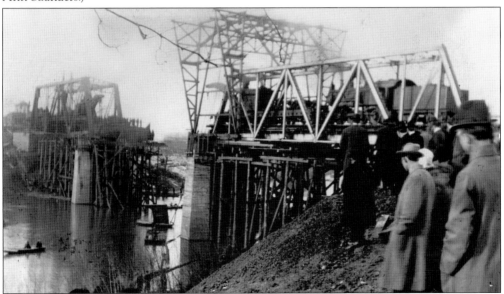

Crews aboard two locomotives and two cranes work to rebuild the collapsed bridge. It took three cranes to retrieve the fallen locomotive—the heaviest engine to try to cross the span that fateful day—and Webber's frozen body from the river. Shop crews rebuilt the locomotive, no. 820, and it ran for at least 35 more years. (Courtesy of Special Collections, Marshall University.)

C&O's passenger service at Guyandotte ended early, and crews quickly tore down the station. Even the sign that replaced the building is losing some paint and starting to be hidden by weeds in this 1973 image. B&O's service lasted longer, but its depot was closed and torn down in 1934. (Courtesy of the *Herald-Dispatch*.)

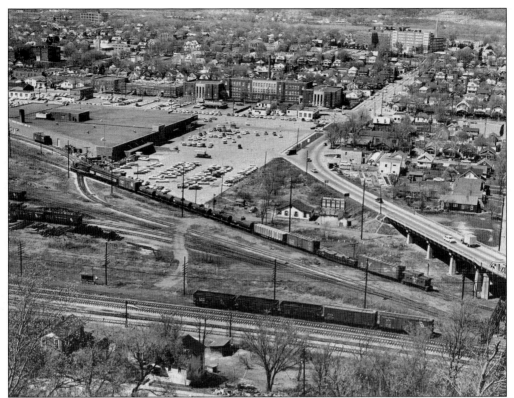

B&O mixed passenger and freight train no. 81 has picked up six tank car loads of gasoline at the Gulf Refining Co. bulk depot spur a mile east of Guyandotte and pushed them to the Guyandotte siding to place them in the proper position in the train. It is heading out of Guyandotte for Huntington in the summer of 1960. (Courtesy of John. P. Killoran.)

Several cars on B&O freight train 103 derailed right beside Guyandotte Elementary School on February 7, 1975. Fortunately, the wreck happened during the wee hours of the morning, so no schoolchildren or other pedestrians were in the immediate area. No one was injured, and the only problem was a bit of snarled traffic. (Courtesy of the *Herald-Dispatch*.)

B&O train no. 72 departs Guyandotte for Pittsburgh on the afternoon of Sunday, September 27, 1953. The train size is deceptive. Overnight train no. 77 from Pittsburgh had concluded its final trip that morning, and its locomotive and cars were deadheading back to Parkersburg, West Virginia. B&O's Guyandotte service survived long after C&O's—first with a combination passenger and

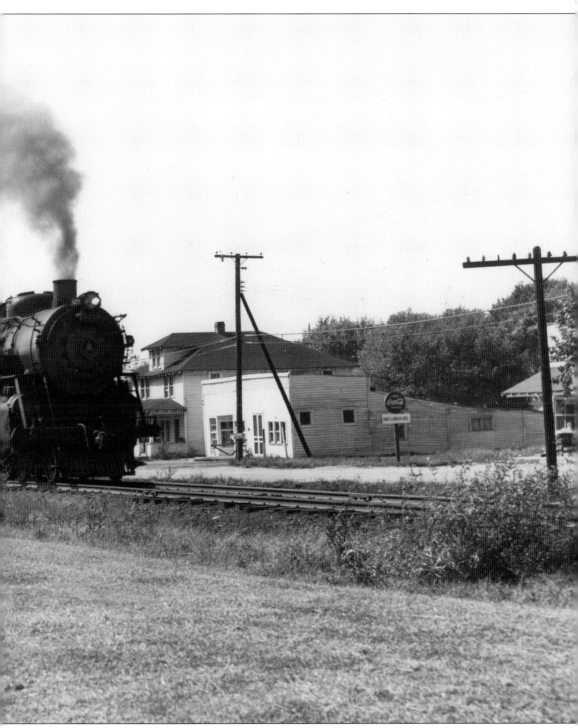

baggage car on a freight train and eventually with a caboose—until April 30, 1971, after which Amtrak took over most of the nation's rail passenger service. Of course, in those days Guyandotte was a flag stop, meaning trains stopped there only if passengers showed up and flagged them down with white handkerchiefs. (Courtesy of Charles Lemley.)

Saturday, September 10, 1977, has dawned warm, sunny, and gorgeous. A giant locomotive charges across C&O's strong, modern bridge into Guyandotte—without stopping—at about 9:00 a.m. with a 19-car New River Train excursion to Hinton, West Virginia. The *Chessie Steam Special* was touring the C&O and B&O system in celebration of B&O's sesquicentennial. (Courtesy of the Collis P. Huntington Railroad Historical Society.)

Another train rumbles through Guyandotte without stopping. It is May 19, 1984, and the Chessie System—a marketing moniker for C&O and B&O—is taking railroad employees on an outing to Ravenswood, West Virginia, aboard a two-locomotive, 19-car excursion headed by an Amtrak diesel. The B&O station is gone now, and the streets are paved, but the second Guyandotte Elementary School will survive a few more years. (Courtesy of Bob Withers.)

*Nine*

# HAPPY DAYS
# OF CELEBRATION

Organizers of Guyandotte's 1910 centennial produced this souvenir booklet, which contains 96 pages crammed full of historical information, photographs, and advertisements that paid for its production. The cover shows the Bukey House, a stagecoach inn at the foot of Richmond Street where Presidents Washington, Lincoln, and Grant are known to have slept. (Courtesy of Mary Margaret Hennen Withers.)

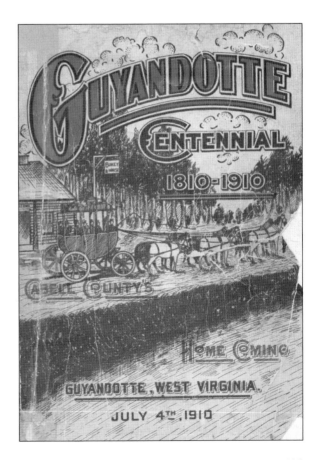

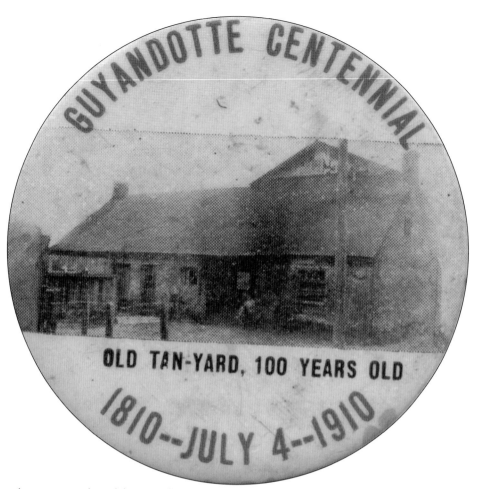

GUYANDOTTE CENTENNIAL

OLD TAN-YARD, 100 YEARS OLD

1810--JULY 4--1910

Another souvenir for celebrants of Guyandotte's centennial is this badge, which shows John B. Hite's tanning yard building. It was built in 1810 facing an alley between the 200 blocks of Main and Richmond Streets. Hite was one of the town's original trustees and was among the founders of the Guyandotte Bridge Co., which constructed the town's first bridge across the Guyandotte River. (Courtesy of Mary Margaret Hennen Withers.)

It is April 20, 1959, and Cabell County is getting ready to celebrate its sesquicentennial. Guyandotte's 150th will follow the following year. Here, Erna Christian (left) and Florence Edwards—members of the Guyandotte Woman's Club—pose with Huntington mayor Harold Frankel as they admire a historical marker at the corner of Bridge and Main Streets. In the background is an old Guyandotter known only as "Jiggs." (Courtesy of the *Herald-Dispatch*.)

Bicyclists Larry Smith, wearing the derby, and Royce Adkins, whose two-wheeler is decorated with five American flags, wait beside a reviewing stand at the corner of Bridge and Main Streets for Guyandotte's sesquicentennial parade to begin at 10:00 a.m. on Monday, July 4, 1960. The reviewers have not showed up, so the march will start a little late. (Courtesy of Bob Withers.)

# DISCOVER THOUSANDS OF LOCAL HISTORY BOOKS
## FEATURING MILLIONS OF VINTAGE IMAGES

Arcadia Publishing, the leading local history publisher in the United States, is committed to making history accessible and meaningful through publishing books that celebrate and preserve the heritage of America's people and places.

## Find more books like this at
## **www.arcadiapublishing.com**

Search for your hometown history, your old stomping grounds, and even your favorite sports team.